Tony Couch's Keys to Successful Painting

Tony Couch's Keys to Successful Painting

BY TONY COUCH

NORTH LIGHT BOOKS

Cincinnati, Ohio

Tony Couch's Keys to Successful Painting. Copyright © 1992 by Tony Couch. Printed and bound in Hong Kong. All rights reserved. No part of this book may be reproduced in any form or by any electronic or mechanical means including information storage and retrieval systems without permission in writing from the publisher, except by a reviewer, who may quote brief passages in a review. Published by North Light Books, an imprint of F&W Publications, Inc., 1507 Dana Avenue, Cincinnati, Ohio 45207. First edition.

96 95 94 93 92 5 4 3 2 1

Library of Congress Cataloging in Publication Data

Couch, Tony.
 [Keys to successful painting]
 Tony Couch's keys to successful painting / Tony Couch.
 p. cm.
 Includes index.
 ISBN 0-89134-427-6
 1. Painting—Technique. I. Title.
ND1500.C677 1992
751.4—dc20 92-9101
 CIP

Edited by Greg Albert
Designed by Paul Neff

ABOUT THE AUTHOR

Tony Couch received his bachelor's degree from the University of Tampa and also studied with Edgar A. Whitney at the Pratt Institute in New York City. He has written articles on watercolor instruction for North Light, American Artist *and* Palette Talk, *and has produced a popular series of videotapes on watercolor painting. He teaches popular watercolor workshops throughout the United States and abroad and has won more than fifty art awards. Couch is a member of the Knickerbocker Artists, Salmagundi Club, the Society of Marine Painters and Watercolor West.*

All illustrations in this book are watercolors by Tony Couch unless otherwise stated.

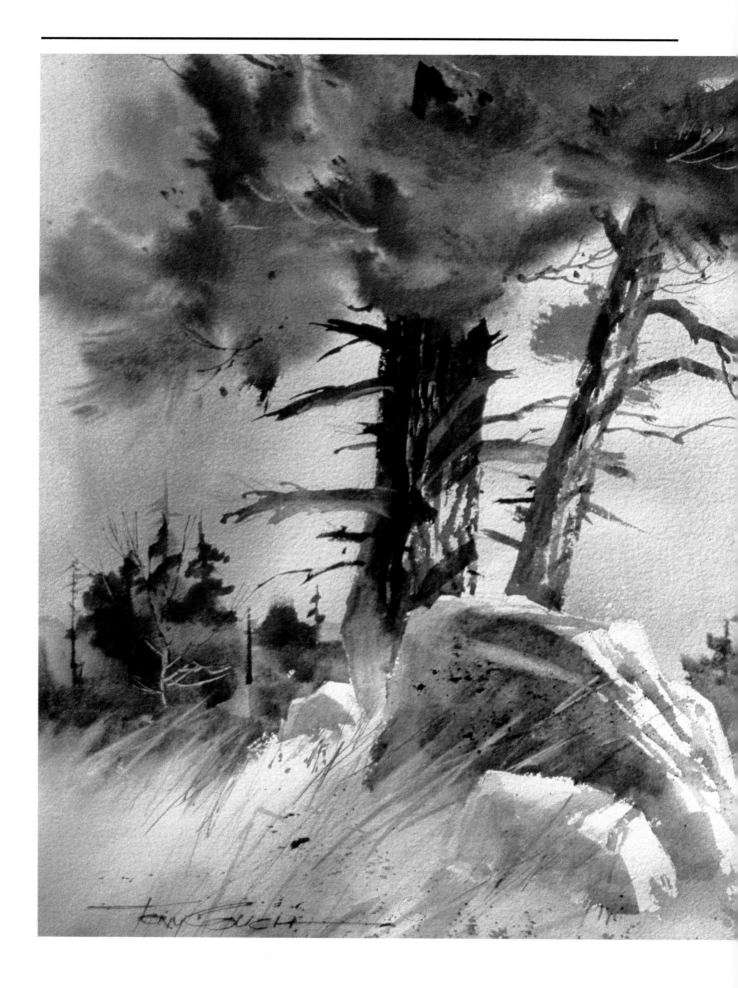

DEDICATION

Dedicated to all who are determined to produce better work, with little regard for the time it may take and the trouble it may be. They not only can, but will, do it.

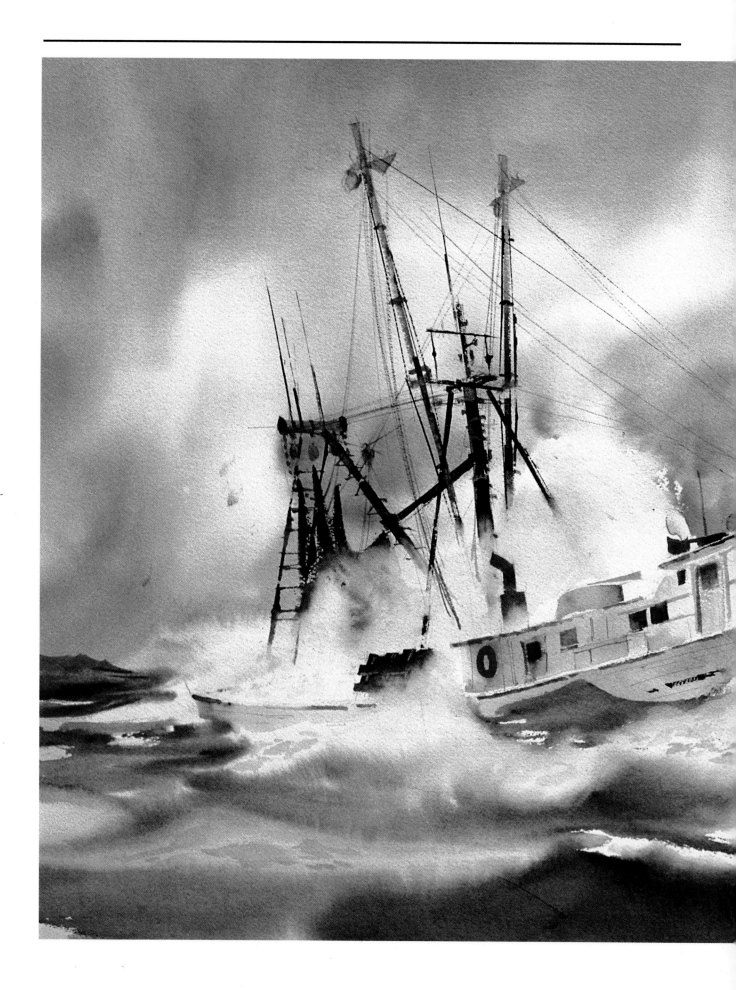

ACKNOWLEDGMENTS

This book wasn't a one-man project. Somebody had to take up the slack and keep the rest of the world off my back while I procrastinated, typed a little, painted a little, and procrastinated some more — my bonny wife Bonnie did her usual sterling job of that.

And there was the influence and urging of my editor, Greg Albert, who hatched the idea for the book, outlined it and produced all manner of other support. He even bought lunch one day.

My thanks to Greg, David and the army of designers, writers and other craftsmen and women at North Light who shepherded this book to completion.

TABLE OF CONTENTS

**Rainy
Day**
22 × 30

Introduction

I paint only for myself—so I don't care what others think of my work." Have you ever heard an artist say that? I'm always suspicious. Artists paint for themselves like actors perform only in seclusion and opera singers sing only in the shower.

We paint to create something others will enjoy—even admire. And we enjoy producing those paintings we think others will like.

That being the case, wouldn't it be nice to know a few things anybody can do with the shapes, lines, colors, values and textures we put on a surface that would guarantee others would like the painting?

Artists have been trying to do this for centuries, and you would think by now someone would have figured out a simple, sure way to do it. As a matter of fact, someone has. Who it was, how it was done, and how long it took is neither known nor important to us.

What is important is that there are eight things anyone can do to attract any audience to a painting. Artists have known about these principles since at least the Middle Ages and have given them names:

Dominance *Variation*
Balance *Alternation*
Contrast *Harmony*
Gradation *Unity*

Collectively they're called "design," or "the eight principles of design."

The reason they work is simple. These eight "principles" are, in fact, really just eight principles of human nature—eight ways all of us are the same.

Even though each of us is a distinct character with our own likes and dislikes, there still are many ways we are exactly the same. Here are eight of them that can be designed into any painting so anyone with a human nature will empathize—or feel comfortable with—your work.

These principles of design are as valid now as they were in the fifteenth century—as they will be two hundred years from now—for this precise reason: human nature hasn't and won't change.

The marvelous thing about it is that learning to use them is not a major problem once you understand what they are and see how they can be applied to the shapes, sizes, lines, directions, colors, values and textures in your paintings. In fact, that's what this book is about. I'll make it easy to understand, and then I'll show you how to do it!

Mike
22 × 30

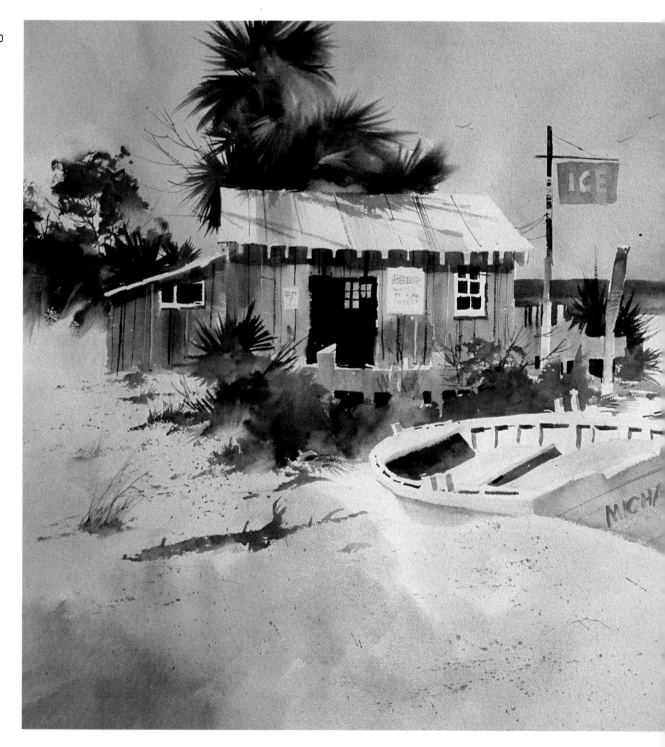

CHAPTER ONE
Principles & Elements

The principles of design are valid because they're based on the principles of human nature. In other words, they are based on the ways all of us are the same, and they can be designed into any painting.

As you might suspect, these principles apply not only to graphic art but to *all* the arts. They apply equally well to literature, speech, drama, choreography, music, photography, interior and industrial design—even flower arranging. However, in this book we're only concerned with these principles as they apply to the fine art of painting.

The Elements of Design

Since we'll be talking about painting, it would be helpful to first break "the painting" down to its component parts, naming each, so when we discuss paintings we're all "singing from the same book."

Similarly, if this were a book on anatomy, the study of the human body, it would make sense to first list and name the parts of the body: hands, arms, fingers, head, etc.

There are seven major parts of any painting. They are:

Size	*Color*
Shape	*Value*
Line	*Texture*
Direction	

These have also been called the seven "elements" of design because they are the raw materials from which we build a design.

The Principles of Design

There are eight principles of design. They are the eight things we can do to any of our raw materials—the "elements"—to build a design. The principles are:

Dominance	*Variation*
Balance	*Alternation*
Contrast	*Harmony*
Gradation	*Unity*

In fact, each of the principles can be applied to each of the elements. For instance, any color in a design (that is, a painting) can be:

Gradually changed to another color (Gradation)
Used with a variety of other colors (Variation)
Alternately placed between colors (Alternation)
Placed next to a similar color (Harmony)
Placed next to a complementary color (Contrast)
Balanced in hue, chroma and value (Balance)
Made the dominant color (Dominance)
Used to make the design a unit (Unity)

Although it is certainly possible for each of the principles to be applied to each of the elements in a design, it's not necessary, or even practical, in most cases. For instance, dominance applied to three or four of the elements will probably be enough for a successful design.

The elements are what we *have*; the principles are what we *do*.

The Design Test

You're probably already familiar with much of what design is; you've learned it intuitively so that it has become second nature to you. Here's a test to measure how much of this sense of design you already have.

Before reading on, look at the nine pairs of diagrams that follow and select which most appeals to you.

In the first case, you probably picked 1A. It is a more pleasing design because there is greater variety in its elements than in those of 1B.

For instance, the lines in 1A are more varied in width and length than in 1B. The variety in size of the shapes and the interval between them is greater in 1A than in 1B. The principle involved here is *variation*.

If 2A looks better to you than 2B, it's no surprise. It's much more interesting than 2B because of the great contrast in size and color between the three balls. None of that exists in 2B where all balls are the same size and color. The dynamic appearance of 2A comes from the dominance of one ball (the yellow) and the variation in size and interval between it and the other two. This is much more entertaining than the

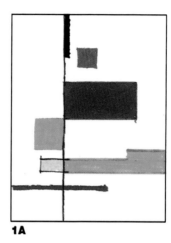

1A

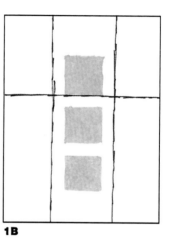

1B

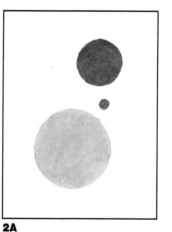

2A

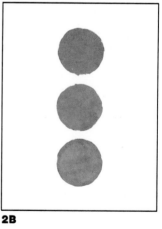

2B

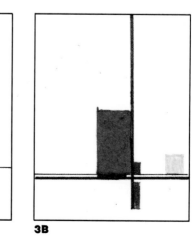

3A

3B

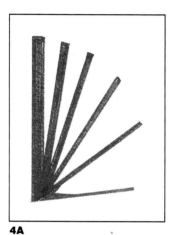

4A

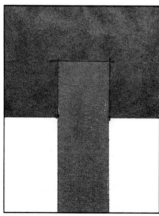

5A

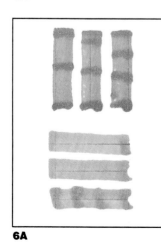

6A

4B

5B

6B

static appearance of the three balls in 2B, in which no shape is dominant and there is no variety in them or the interval between them. The principles involved here are *contrast*, *dominance* and *variation*.

You probably like 3B better than 3A. That's understandable; there is so much weight to the right of 3A that it's off balance. The appearance of 3B, on the other hand, is balanced. We feel much more comfortable with that. The principle involved here is *balance*.

Did you prefer 4A? It is a better design because of the "entertainment" inherent in the gradual change in thickness, direction and length of the lines in it. The design of 4B, on the other hand, is boring because of the lack of any change in its elements. The principle involved here is *gradation*.

Are you more comfortable with 5B than 5A? It's because the two sections in 5B are not the same size; the striped section appears more important because of its larger area. The principle involved here is *dominance*.

If you picked 6B over 6A, you're correct. The design in 6A has two unrelated sections: one with vertical bars, the other with horizontal bars. The design in 6B, on the other hand, seems unified because the vertical bars appear on either side of the design. The principle illustrated here is *unity*.

You're probably more entertained by 7B than 7A. The design of 7B is more interesting because it alternates between long, thick lines and short, thin ones—while 7B is a row of the same thick lines. The principle here is *alternation*.

If you like 8A more than 8B, it's because of the gradual change in value in 8A, while 8B has the same color with no change. The principle here is *gradation*.

Do you find 9B more interesting than 9A? It's because the two sections in 9B are much different from each other. One is small and dark while the other is large and light. Their hues are also directly opposite on the color wheel. On the other hand, the two sections in 9A are the same size, and are of similar hue and value. The principle at work in 9B is *contrast*.

Although you might have chosen one or two that don't agree with my choice, for most people, most of the time, the ones I suggested will be considered better. Now let's look at how using the principles of design is the key to painting successful paintings, time after time after time.

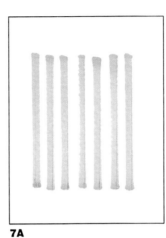

7A

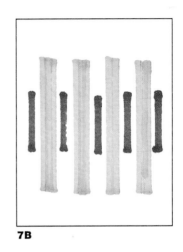

7B

8A

8B

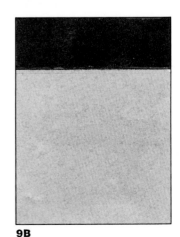

9A

9B

Down Home
22×30

While the eight principles of design *can* be applied to all seven elements (parts) of a painting, it doesn't happen often. If there is a dominance of three or four of the seven elements, it is probably a good painting. If you've used gradation of value or hue in only three or four places, your painting will be far superior to one with no gradation.

In the painting above, you find that most of the principles are applied to most of the elements. Cool colors, straight lines and an-gular shapes dominate, giving the painting unity. However, a design unit without variation and contrast would be boring, so the cool colors are varied with touches of warm, the straight lines are contrasted with some curved lines, and soft curved shapes contrast with the angular ones. Many of the colors are graded from cool to warm and many of the values graded from light to dark to make the painting interesting, but none of these changes are so great that the picture lacks harmony. The result is a pleasing painting that attracts and retains the viewer's attention.

In chapter eleven, find out why the principles of dominance and unity create a pleasing sense of order in a painting.

Sunset Surf
by Sharon Rickert
22 × 40
oil on canvas

The principles of design can be applied to any subject matter painted in any medium. For example, in this painting by Sharon Rickert, you can see how she uses these principles to create a compelling image of the sea and surf. The cool colors dominate the scene but are balanced and contrasted by the warm glow of the sun. There is a variety of textures, but the rough texture of the surf dominates.

In chapter twelve, learn how to direct the viewer's attention by creating paths for the eye.

© John Kluesner

Distant Arbor
by John Kluesner
35 × 45
oil pastel

Knowing the principles of design can help you analyze a painting to find out why you like it. This analysis can be very instructive; every good artist studies the works of others to learn more about good design. In this oil pastel by John Kluesner, you can see how color dominance is created by using more blues and greens than any other color. Eye-catching contrast is created with the warm colors versus the cool colors; for instance, interesting contrast is created with touches of warm colors in the cool shadows and touches of cool colors in the warm sunlit areas.

In chapters five and eight, discover how to make color work for you.

Autumn Splendor
by Foster Caddell
24 × 30

A well-designed painting is no accident; a knowledge of the principles of design allows you to plan for success. In *Autumn Splendor*, it's obvious Foster Caddell considered the placement of lights and darks *before* he began. He tucked the small light shape into the end of the large dark tree "tunnel" to lead you precisely to that spot. The value pattern here is the third of the "Big Four +2" that I describe on page 55.

Chapter six shows you a dozen basic value patterns you can use to make more powerful pictures.

CHAPTER TWO
Shape & Size

A shape is a two-dimensional pattern such as a circle, square, rectangle, triangle—or a combination of these. It may be a realistic rendering of an object (realism), a distorted but recognizable object (abstract art), or a shape unrecognizable as an object (nonobjective art).

Although the variety of shapes an artist might produce is infinite, all will fit into three broad categories: angular, curved or rectangular.

It's important to remember that although angular, curved and rectangular shapes may all be in a painting, only one of these types should be dominant. A description of how to make any element dominant starts on page 93.

If you're a painter or graphic designer, you're in the shape-making business. Edgar A. Whitney admonished his painting classes: "We are *shape makers*, symbol collectors and entertainers." That being the case, it's useful for a painter to have all the information available about shapes . . . and there's quite a bit available.

A shape is a two-dimensional object, such as a circle, rectangle, triangle or a combination of these.

The Boring Shapes

Did you know shapes can be boring or interesting? It just depends on how we make the shapes. Fortunately for us, there are only three boring shapes in the world: the square, the circle and the equilateral triangle.

They're boring because there is no variation in their dimensions. All sides of the square and equilateral triangle are the same length. The degree of curve and diameter of the circle are the same no matter where we measure.

This lack of variation, or change, is boring in any circumstance. For example, a speaker who drones in a monotone with no pauses or changes in inflection will put you to sleep. Similarly, we easily tire of a singer with only one song or of a daily routine with no variation.

Because you, as a painter, seldom portray these geometric shapes, you may think this is of little consequence; therein lies the trap! Where we get into trouble is not in painting them, rather it is in painting objects that will fit *into* them!

If a house's top-to-bottom dimension is the same as its side-to-side dimension, the solution is to change one of the dimensions.

If the foliage of a tree fits into a circle, the solution is to either change the shape into two different dimensions, or add another shape to it to create a larger shape of different dimensions.

If a mountain fits into an equilateral triangle, the solution is to change its sides so they are of different lengths and angles.

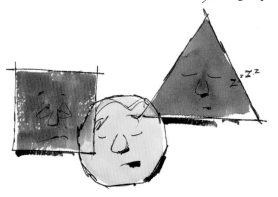

These are the boring shapes: a square, a circle and an equilateral triangle.

The foliage of a tree is boring if it fits into a circle. Change the shape into two different dimensions, or add another shape.

A house whose top-to-bottom dimension is the same as its side-to-side dimension is boring. The solution: change a dimension of the house.

The Triangle

Triangular shapes deserve special attention. I cautioned you about the equilateral triangle, which has three sides that are the same. A triangle with only *two* identical sides is just as boring.

The triangle of two equal sides plays a trick on you by lying on its side or standing on its head so you won't recognize it. But it's just as boring, and so is the shape you put inside it.

Again, the solution is to change the angle of one of its sides.

I should caution here that when I speak of boring shapes and the shapes that fit into them, I mean the large, easy-to-see shapes in a painting, not the small incidental shapes that make up the larger shape. For instance, a house is a large shape, but the windows and angles of the roof are incidental to this larger shape.

Some objects, such as particularly shaped signs, are "boring" shapes, but they must be painted that way for identification. A yield sign is an equilateral triangle and must be painted that way or it will no longer look like that type of sign.

The Interesting Shapes

All of the other shapes are interesting. However, some are more interesting than others. The most entertaining shapes have two different dimensions, are oblique or have an oblique thrust, and have "incidents" at the edges.

When a shape has two different dimensions, it is wider than high or higher than wide. You can see this alone eliminates the boring square,

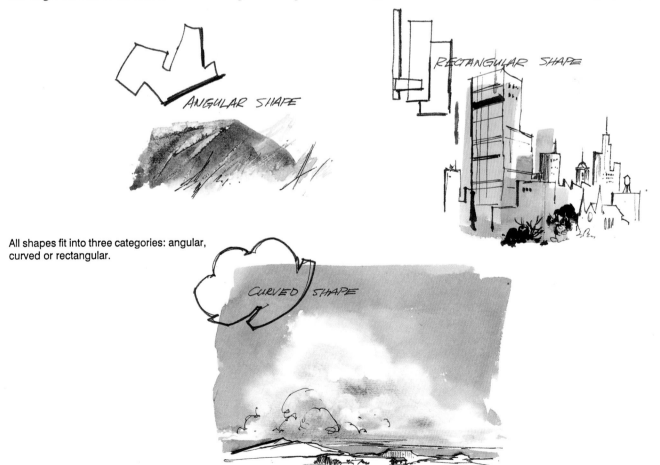

All shapes fit into three categories: angular, curved or rectangular.

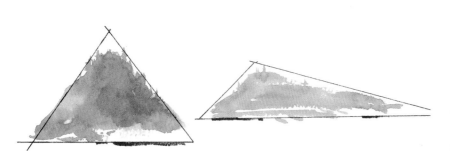

A mountain that fits into an equilateral triangle is boring. Change its sides so they are of different lengths and angles.

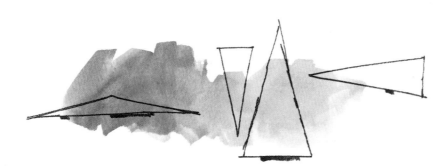

Any triangle that has just two sides of the same length is boring.

A triangle with two equal sides is boring even when lying on its side or turned upside down.

circle and triangle with three equal sides.

Oblique means slanted or at an angle. It's anything that isn't horizontal or vertical. Horizontal or vertical lines or shapes give the illusion of being static, or still.

A line or shape that is oblique, or has at least one side oblique (that's the oblique thrust I was talking about), gives the illusion of movement. Anything that appears to move, of course, is much more interesting than anything static.

Incidents at the edges means something should be happening at the edges of the shape — things should stick out of it or down into it. These "ups and downs" at the edge should be varied; the height (or depth) should be varied, as should the incidents between them.

It's important that this happens at the edge of a shape because we pay much more attention to a shape's silhouette than to anything in its interior.

The diagram next to the painting, see page 16, points out the incidents at the edge of three shapes: the cloud (blue arrows) the fishing boat (black arrows) and the weeds (orange arrows). Also note that every shape in the painting has two different dimensions: they're wider than high. They are also oblique: the highest thrust of the cloud is at the upper right; the boat sits at an angle and lies tilted to portside; and the field of grass is higher on the left and disappears out the bottom at the right.

Negative and Positive Shapes

The positive shapes are those we intentionally put into the design. In the process, the rest of the blank surface is divided into areas that are the negative, or incidental, shapes.

The negative shapes are nonetheless shapes, so they must be well designed. They must have two different dimensions, be oblique, and have incidents at the edges.

Negative shapes are not a major concern to the painter because generally they will be well designed if the positive shapes are well designed. Still, it pays to monitor negative as well as positive shapes as you paint. Some may turn up as one of the three boring shapes and you'll want to correct that on the spot.

Size

It comes as no surprise to anyone that shapes and lines, as well as areas of color, value and texture can be made a variety of sizes. And that's all *size* means in the list of design elements shown a few pages earlier.

No two of anything should be the same size. As we shall soon see, to do otherwise would be to violate the principles of variation, harmony, contrast and, very likely, dominance. The price for this oversight is a painting with boring areas.

In addition, size can be used to produce drama or emphasize the importance of any element in a painting. For example, a painting with large waves and a small boat would illustrate the power of the sea.

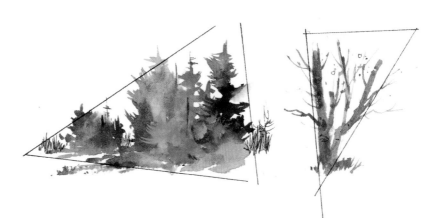

Change one of the sides or one of its angles to make the shape interesting.

A line or shape that is oblique or has an oblique thrust is dynamic and therefore more interesting than a vertical or horizontal one, which is static.

The rock at left is much less interesting than the one at right because it lacks incidents at its edges.

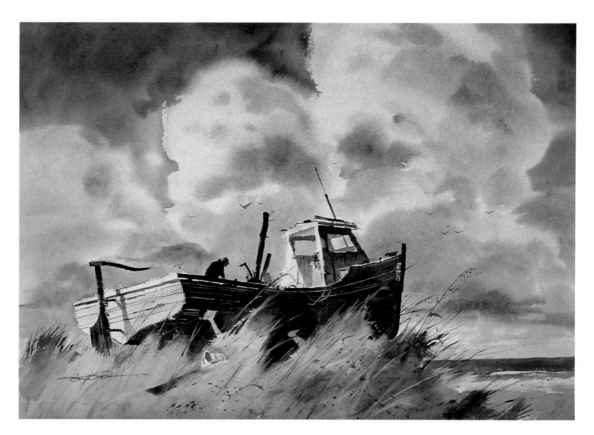

Seaworthy
22 × 30

The diagram points out the incidents at the edges of three shapes. Notice that every shape in the painting has two different dimensions and is oblique or has an oblique thrust.

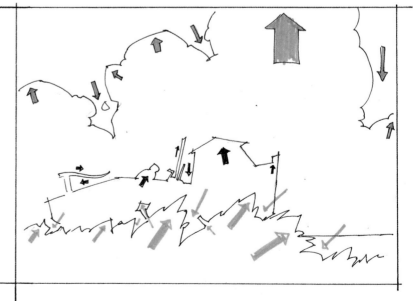

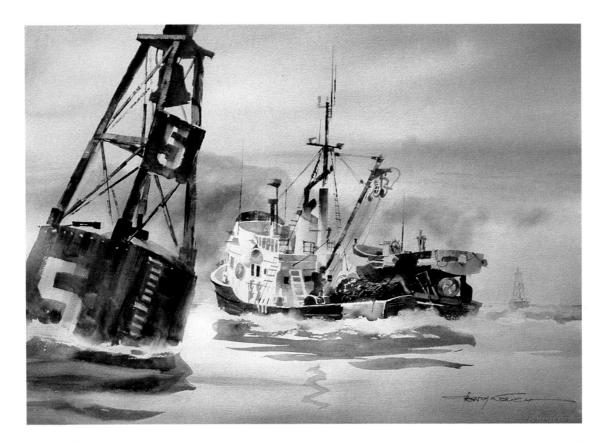

End of the Channel
22 × 30

Negative shapes must be well designed, too, with two different dimensions, an oblique thrust, and incidents at the edges.

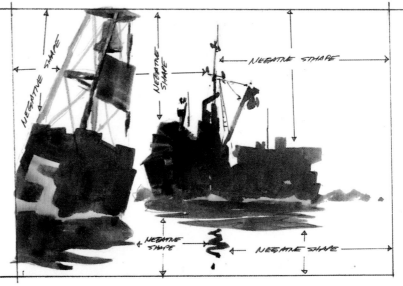

The Neighbors
22×30

Line & Direction

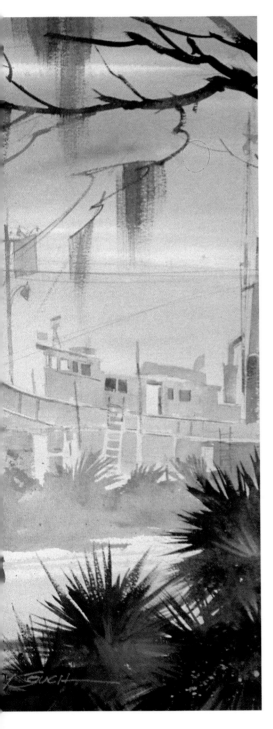

There are only two types of lines, curved and straight. Angular lines are collections of straight lines.

*T*here are only two types of line in any design: curved and straight. There *are* angular lines, but these are merely a collection of straight lines.

Identifying lines in a painting is no great problem; if it *looks* like a line, that's what it is. They might be long or short, thick or thin, curved or straight.

It's important in a design that there be a dominance of either straight or curved lines. There are four ways to make any design element dominant (see "How to Make an Element Dominant," page 93), but for lines the simplest is merely to put in more of one type than any other.

The diagram, see page 20, of *Halifax Harbor* makes it easier to find the lines in this painting. As you can see, the straight lines are dominant.

Direction

There are three possible directions: vertical, horizontal and oblique. Oblique is anything that isn't horizontal or vertical. We are more comfortable with a design that has a directional dominance than a design without one.

The directional dominance of a design is determined by the lines, the linear shapes and the dimension of the surface on which we paint in the case of a horizontal or vertical dominance.

For instance, a paper or other surface with a horizontal format would help make a painting dominantly horizontal, and one with a

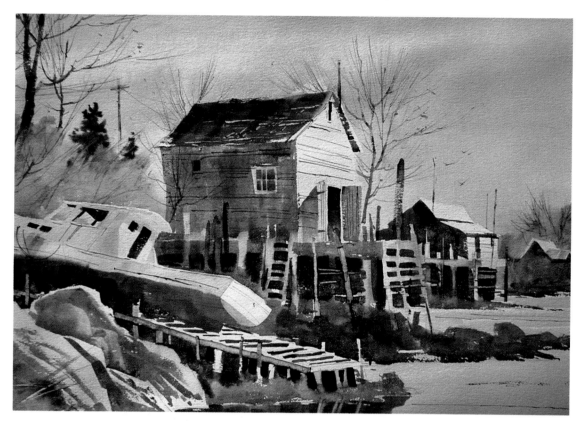

**Halifax
Harbor**
22 × 30

As you can see in the diagram, straight lines
are dominant in this painting.

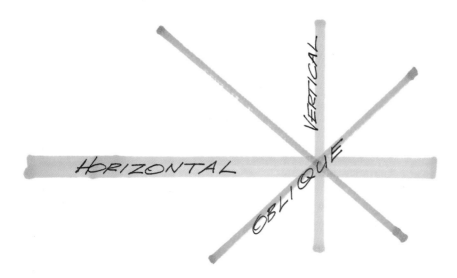

There are only three possible directions: vertical, horizontal and oblique.

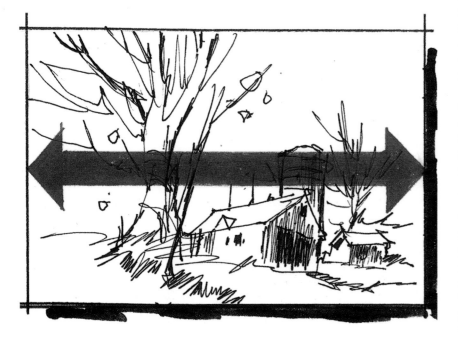

The dimensions of the surface on which you paint help determine the directional dominance of a painting.

vertical format would be a strong factor in a vertical dominance.

This is not to say a vertical dominance could not be produced on a horizontal surface; it only means more vertical lines and shapes will have to be used to overcome the horizontal thrust of the surface.

For an oblique dominance, it's the lines, the linear shapes and the *angular* shapes that do the trick. Since paintings are traditionally done on horizontal or vertical rectangles, there is no help from this quarter, and the artist must make good use of lines and shapes to produce the oblique effect.

Horizontal

In *Lookout*, on page 22, there are more horizontal lines and long horizontal shapes than vertical or oblique, which, with the horizontal dimension of the paper, gives this design a horizontal directional dominance.

These horizontal shapes are shown in the diagram: the clouds (gray), the piece of land (yellow), the fence/building group (white outlined in black), the sea and puddle (green) and the beach (white).

Vertical

The greater number of vertical lines and linear shapes gives *Fat Fir II*, see page 23, a vertical directional dominance—even though the dimension of the paper is horizontal. The diagram helps you see those shapes that give it the vertical thrust, including the soft, nonobjective brushstrokes in the foreground and sky.

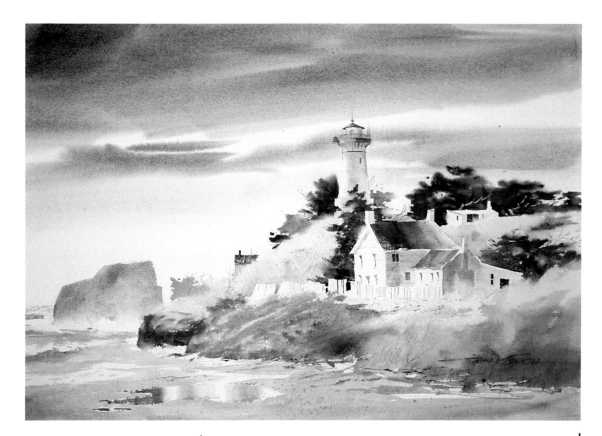

Lookout
22 × 30

In *Lookout*, right, there are more horizontal lines and long horizontal shapes than vertical or oblique. This and the horizontal dimension of the paper give this design a horizontal directional dominance.

These horizontal shapes are shown in the diagram: the clouds (gray), the piece of land (yellow), the fence/building group (white outlined in black), the sea and puddle (green), and the beach (white).

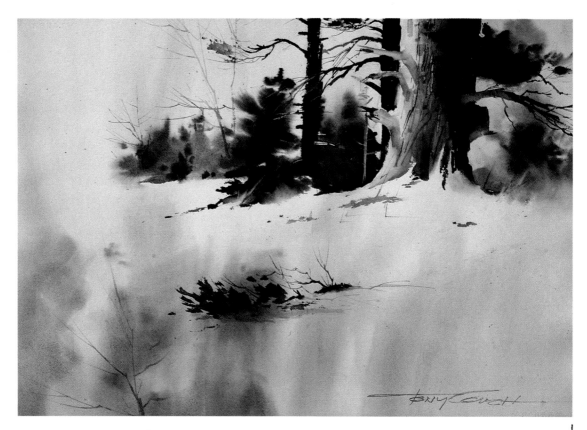

Fat Fir II
22×30

The greater number of vertical lines and linear shapes gives *Fat Fir II*, left, a vertical directional dominance—even though the direction of the paper is horizontal. The diagram helps you see those shapes that give it the vertical thrust, including the soft, non-objective brushstrokes in the foreground and sky.

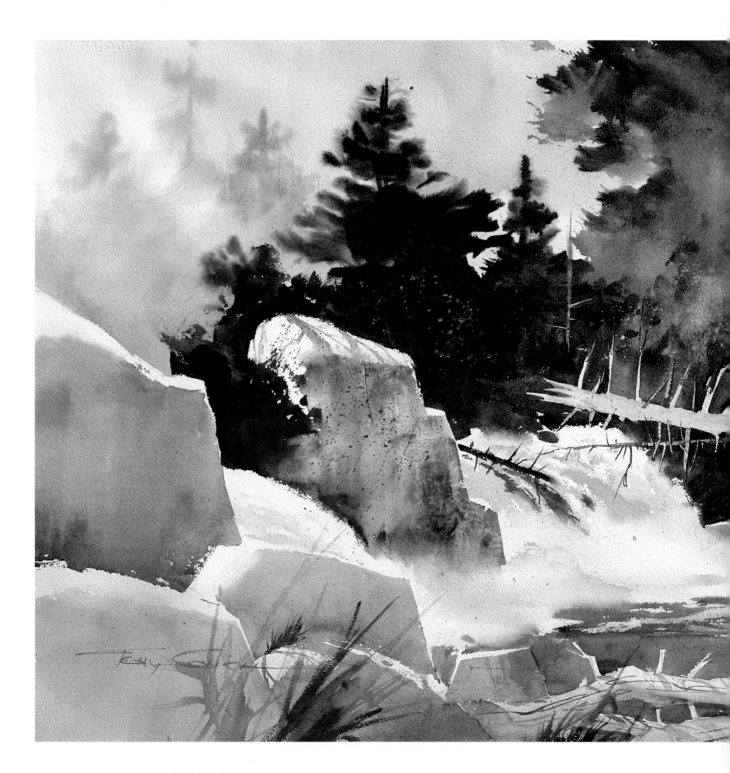

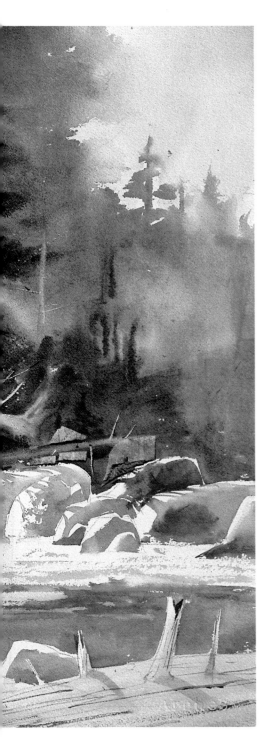

Oblique

The oblique directional dominance of *Waterworks* is assured by the great number of oblique lines *and* angular shapes. The abstract of the painting may help you identify them.

More examples of linear and directional dominance can be found in the paintings on pages 28-29. Most paintings will have curved or straight lines in many different directions, but still one type of line

Waterworks
22 × 30

The oblique directional dominance of *Waterworks* is assured by the great number of oblique lines *and* angular shapes. The abstract of the painting may help you identify them.

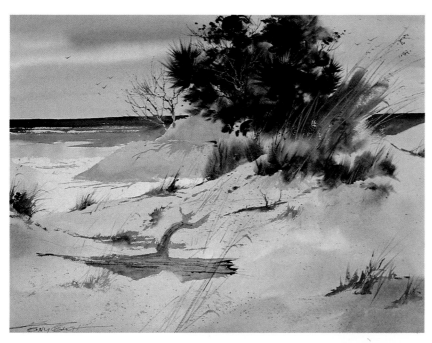

A Drifter
22 × 30

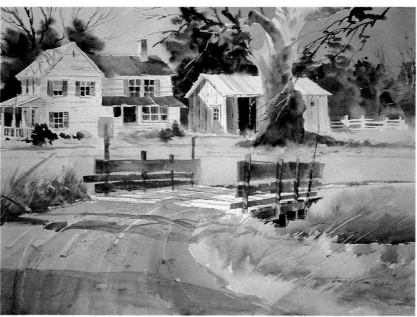

Sycamore Crossing
22 × 30

Examine these paintings carefully and determine the dominant line type and direction. Notice that most paintings will have curved or straight lines in many different directions, but a design will be more interesting and satisfying if one type and direction of line is dominant.

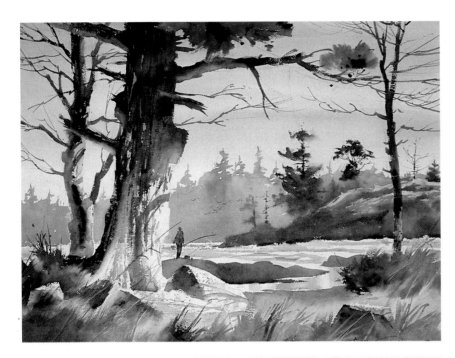

Here's a Good Place
22 × 30

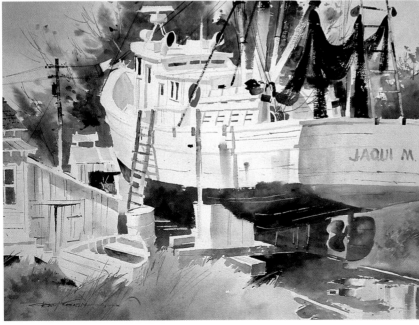

Jaqui M
22 × 30

**Hank's
Buckets**
22 × 30

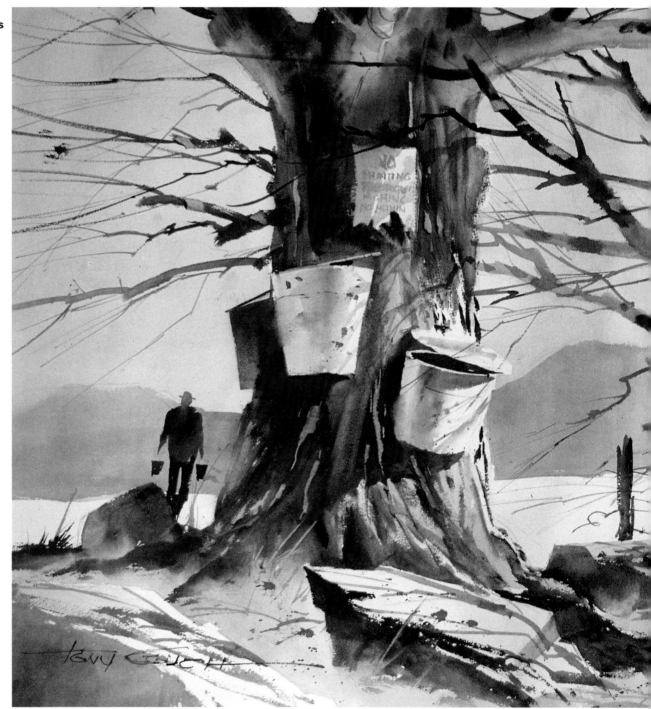

Texture

What Is Texture?

Texture could be described as the nature of the surface of those objects that we depict in a painting. It might be slippery, rough, smooth, hard, soft and so on. Texture is something we normally explore by running a hand over the surface of an object. It's not quite as easy or accurate, but we also can judge the texture of a surface by *looking* at it.

Paintings are "touch-me-nots." We view and evaluate what we *see* in a painting, not what we can feel with a hand. So now if we want the viewer to know the texture of an object in the painting, it must be painted so that it is readily apparent by sight alone.

This actually makes life a little simpler for the artist, as the eye can only discern three general textures, versus the variety that can be felt with the hand. Those three are:

Smooth (hard)
Rough
Soft

Every object in a painting, then, must be depicted in one or more of these three textures. Which will they be? It just depends on what the artist does with the brushes and paint.

The artist only needs to create three basic textures: smooth (hard), rough and soft.

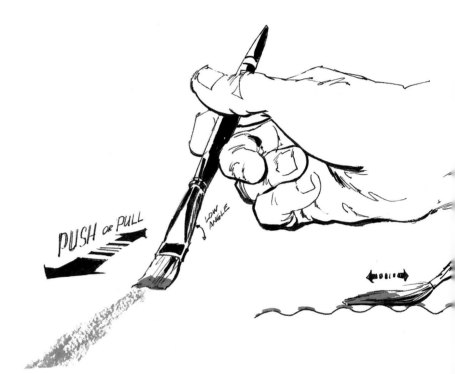

One way to make rough texture in watercolor is to hold a medium wet brush at an angle almost parallel to dry paper and push or pull the brush over the surface.

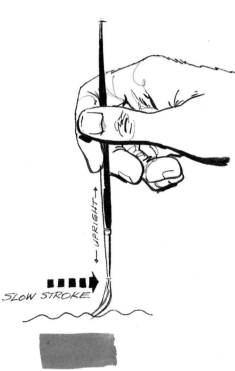

To make a smooth, hard-edged shape in watercolor, hold a loaded brush vertically and make a slow stroke on dry paper.

Smooth Texture

Let's take smooth, or hard, texture first. The physical surface of the paper or canvas is rough. If we could make a trip across the surface and see it as an ant sees it, we would find a continuous sea of regularly shaped hills and valleys.

The problem is to make the shape we paint *appear* to be smooth, even though the surface is rough. To get this smooth effect, every hill and valley on the painting surface must be covered with paint, in the interior of the shape and *particularly along its edges*.

If you're working with watercolor, to get a smooth, hard edge, the paper must be dry and the brush must be loaded with water and soft pigment. You must hold the brush vertical and make a mark on the paper with a slow stroke. Make the tip of the brush do the work. The brush must be vertical to fit down into every valley, and must be moved slowly to give it time to get into each valley. Finally, the brush must be fairly wet so the pigment will flow into these spots.

If you are working with oils, to get a smooth edge, you must have the right paint consistency and use enough pressure on the brush. If the paint is too thick or the brushstroke too light, it won't fill in the valleys of the canvas's weave.

Rough Texture

For rough texture in watercolor, we need the same dry paper and the same brush, loaded as before. This time, however, the brush should be at an angle almost parallel to the paper, and you should use most of the length of the hair, rather than only the tip. The brush can't fit into the valleys, and it paints only the hilltops, which creates rough texture! It helps to move the brush quickly, and pushing rather than pulling the brush often achieves more certain results.

Another method, also on dry paper with the brush loaded, is to make a rapid stroke. Now the brush doesn't have time to get down to the valleys. It leaves only the hilltops covered, with the same results as before.

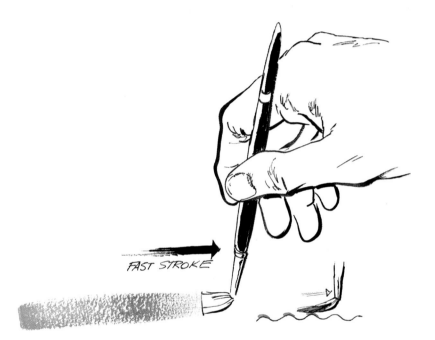

FAST STROKE

Rough texture can also be made with a fast stroke over the paper.

To make rough texture with oils, make a fast, light stroke with the tip of a wet, but not loaded, brush.

A very wet brush will make an uncontrolled soft-edged shape, top. A drier brush makes a soft, but more predictable shape, bottom.

Methods similar to those used by the watercolorist are required to create rough texture in oil paint. However, the canvas must still be unpainted, or the previous paint deposit should be dry or tacky. The brush should not be saturated with paint. Wipe excess paint from the brush and make a light stroke over the canvas. When you are painting over color, this technique is called *scumbling*.

Rough texture is easier for the oil painter to create because the paint itself can be applied in a way that creates real texture. Applying the paint thickly with a brush or painting knife is called *impasto*.

Soft Texture

Producing soft texture in watercolor requires wet paper. Now any mark, with any amount of water and pigment, will net a soft-textured shape. If the brush is very wet, an uncontrolled, unpredictable shape results. This technique is termed "wet on wet."

If the brush is drier, a soft, predictable shape results. This technique is called "dry on wet."

The oil painter will have more control over soft edges. Soft edges require blending with the brush to mix one area of color with the other. Unlike watercolor, oil paint won't create soft edges on its own; the artist must blend them himself.

Dominant Texture

There are two good reasons for giving shapes a particular texture. One is to achieve a textural dominance for the overall painting. There can

and probably will be all three textures in any given painting, but good design requires that one of these three be dominant. This textural dominance is most easily produced by painting a great deal more of one texture than of the other two in the painting.

For instance, *Another Winter*, on page 33, has a soft textural dominance because we see more soft texture than any other. *Fernandina*, on page 33, has a hard/smooth dominance, and *Old Timer*, on page 35, a rough dominance, for the same reasons.

Symbols

Another reason for using a particular texture is to produce a recognizable symbol for an object to be included in the painting. If there is a key to successful painting, it's this: The artist must not paint what she *sees*, shape for shape, color for color—as would a camera. Instead, she must invent a symbol for the object and paint that. Ed Whitney used to point to the subject matter and say, "The language of paint upon a surface is different than what's out there—so a translation job must be done!"

Consider what artists are doing: they're smearing paint on a surface, hoping to make the audience conscious not of paint, but rather of something one might find when looking out a window.

Like any entertainer, then, an artist is in the illusion business. For a painter, that means painting *symbols* for objects, rather than objects. An object's symbol is a "blob" of

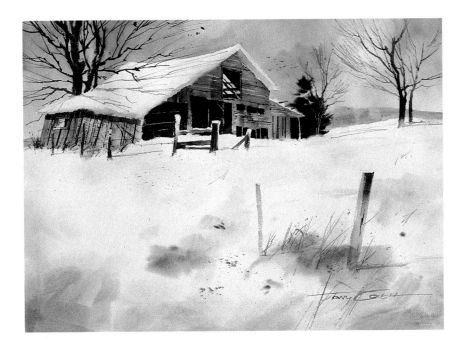

Another Winter
22×30

In this painting, the dominant texture is soft because we see more soft texture than any other. Soft texture dominance is appropriate for a snow scene, because while soft and rough are the textures of snow, soft "says" it best.

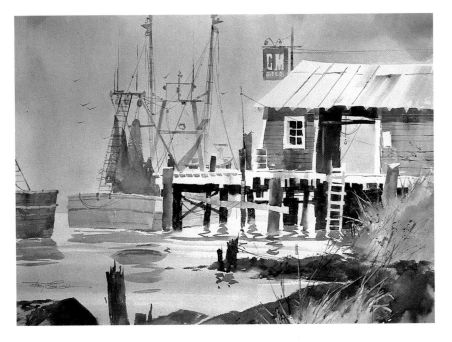

Fernandina
22×30

Hard (smooth) textures dominate in this painting; even the reflections have distinct, smooth edges.

A

B

paint on a surface that has only three characteristics of that subject matter. They are the characteristic *shape*, *color* and *texture*.

Notice I say the *characteristic* shape, color and texture. That means the shape, color and texture the object is *normally*, or *most often*. The stereotype of the object if you like.

Characteristic Shape
For instance, the characteristic shape of a summer cumulus cloud is a rounded, white series of billows. However, I'm sure if you watched the sky continually for a few months, you might eventually sight, somewhere over the earth, a cloud close to a square or rectangular shape. Don't paint it! Leave it for the photographers.

Although we will all believe and marvel at the photograph, *no one will believe your blob of paint is a cloud*. That's because it's not the *characteristic* shape; we're not used to seeing that shape for a cloud, and while we trust the photo, the artist is always suspect.

Similarly, when painting a boat,

automobile or airplane, it might be advantageous to avoid head-on or other hard-to-recognize views since a side or three-quarter view would show off more characteristics of the craft, making your "blob of paint" more easily identified as the subject matter you intend.

It's important to remember, when deciding upon a characteristic shape or texture, to put those characteristics at the *edge* of the shape. That's because we judge shapes first by what we see at the edges, or silhouette. When we come upon any shape, the eye makes a fast, split-second trip around its silhouette and that registers upon the brain, telling us what the object is: a boat, a house, a horse, a figure. Then we go into the *interior* of the shape to judge particulars: *which* boat, *which* house, and so on.

It's nice to get the characteristic shape and texture in the interior of the shape, but they *must* be at the edge or we won't recognize it. A house will never look like a house if it has the silhouette of a tree, no matter how convincing we are at painting windows and doors.

The characteristic texture of a rock is hard (smooth or rough) along the outside, as in *A*. Soft texture at the edge, as in *B*, is not the characteristic texture, so it doesn't look at all like a rock.

We know the top shape is a house because we see "house" in the silhouette. The bottom shape will never look like a house, no matter how cleverly we render windows and doors in the interior because its silhouette *doesn't* say "house."

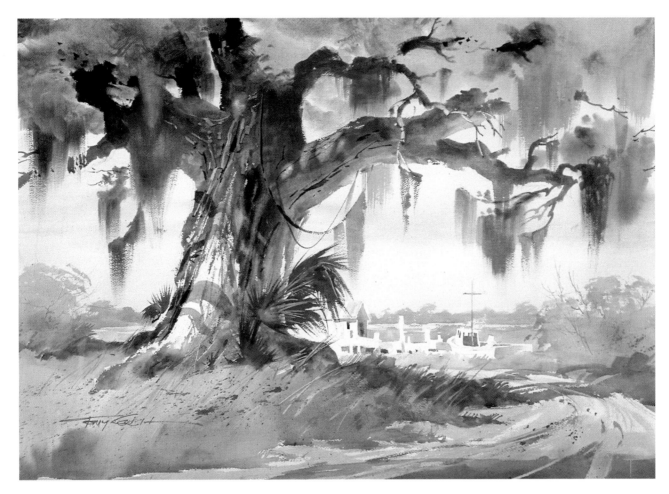

Old Timer
22 × 30

The bark, moss and vegetation have rough textures giving this painting a rough dominance because there are more rough textures in it than any other.

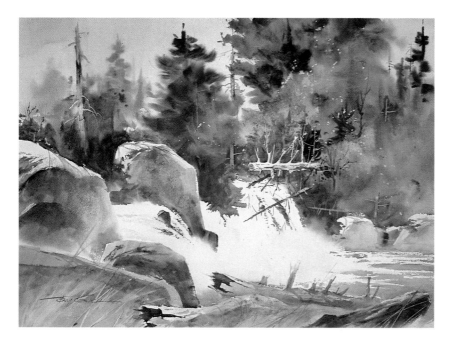

Characteristic Texture

Picking the characteristic texture of an object in nature is simple. If you can't envision what it is, go up and touch it. Your hand is going to feel a surface that is either hard/smooth, rough or soft. Whatever that is, be sure it appears at the edge of your "blob of paint!"

The texture of rock is hard/smooth or rough. So your shape has the best chance of looking like a rock if you use those textures, particularly at its edge. You would *not* use soft texture at the edge, however. Soft texture makes it look like anything but a rock! You can use soft texture in the *interior* of the rock shape; it's only a disaster if you use it at the edge. Note also, the bottom edge of the rock is not seen. It disappears into the surface upon which it sits, and that has its own identify-ing texture: soft or rough if it is water or a field of grass.

Here are the characteristic textures for a few other objects, with the more descriptive texture in bold:

Wood (tree trunks, logs, barn siding): **rough** *or hard*
Steel (metal): **hard** *or rough*
Glass: **hard**
Snow: **soft** *or rough*
Field of grass or weeds: **soft** *or rough*
Individual weed or blade of grass: **hard**, *rough or soft*

Characteristic Color

The only characteristic left is color. Although important, it is not a *great* deal of help, as most things can be any color, within reason. For instance, the foliage on a tree might be dominantly green or yellow/green, with blue/green in the shadows and interior in the summer; it could be brown/green, brown, red and orange in the fall. In the distance it might be blue, and in fog, light gray. If the object is man-made, it's the color anyone might paint it!

More often there are colors objects characteristically are not, and those should be avoided (such as black trees, purple bananas, green snow and so forth). It would be a mistake to use the green of summer foliage on fall trees, or the warm foliage of fall for a spring scene. And you certainly wouldn't give them dark or bright hues and expect us to believe we're seeing them in a fog.

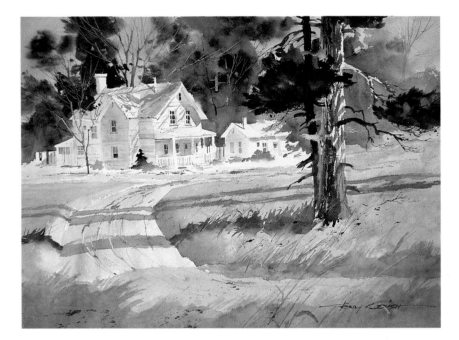

The Neighbors
22 × 30

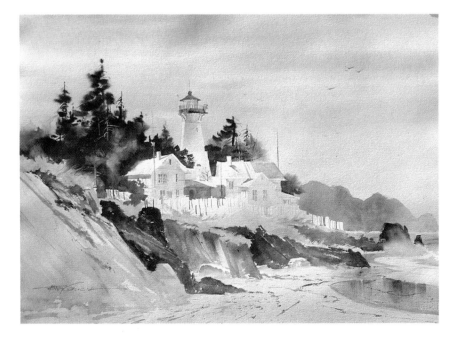

Point Cambria
22 × 30

Although an artist sees shapes and colors, he cannot merely record what he sees as a camera would. Instead, the artist must invent *symbols* for the things he sees and paint them. These symbols must have the characteristic shape, color and texture of the objects he paints for the symbols to be identifiable by the viewer. There should be no question about the identity of the things the artist has painted.

Each of these paintings is really a collection of symbols that say "tree," "rock," "water," etc.

**Winter
Stream**
22 × 30

CHAPTER FIVE
Color

Nothing is more fascinating than color. For that reason, volumes have been written about it. Not all of this vast store of information is useful to the artist; however, I'm interested here only in telling you what you might use to build a handsome design.

To begin, it would be helpful to define terms to be used in this discussion:

Color: The appearance of a surface other than black, white or gray. Just as a box has three dimensions (length, width and height), color has three: hue, value and chroma.

Hue: The characteristic by which we distinguish one color from another—red, purple, blue, yellow, etc.

Value: The darkness or lightness of any hue. For example, dark red versus light red. Value is commonly expressed in a graduated range from one (darkest) to ten (lightest).

A value two red would be a very dark red; value five red is a red midway between darkest and lightest (about what you see in your palette); and a value eight red would be very light, what the layman might call "pink."

Chroma: Brightness (or dullness) of hue. This has also been termed color intensity, color saturation and color strength, among others. As any hue becomes less bright, it progresses toward gray.

This is not to be (but often is) confused with value, which is concerned only with the *lightness* or *darkness* of a hue. It is possible for a color to progress from bright to gray and maintain the same value.

Pigment: The chemical ingredient in paint that gives it color.

Prism: A glass device used to break white light (sunlight) into a band of six colors: red, orange, yellow, green, blue and violet. The same colors are found in the rainbow.

Violet: Blue/purple. One of the colors found in the prism.

Purple: Not in the prism. It is produced by mixing red and blue.

Color Temperature: A warm or cool psychological effect color has on us. The warms are yellow/green,

Violet

Violet is a blue/purple and is one of the colors found in the prism.

Purple

Purple is not in the prism; it is produced by mixing red and blue.

Color **39**

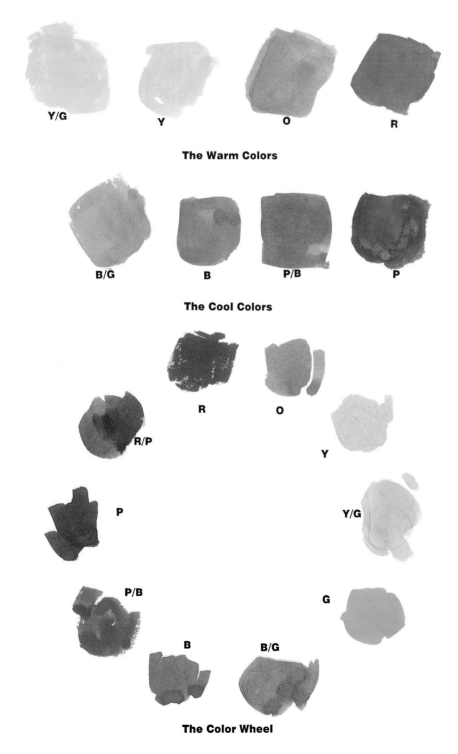

The Warm Colors

The Cool Colors

The Color Wheel

yellow, orange and red. The cools are blue/green, blue, purple/blue and purple. Green and red/purple are neutral, being between the two groups, but this is of little consequence as a little of a warm or cool mixed in instantly makes these neutrals warm or cool.

Primary Colors: So called because nothing can be mixed to produce them; they must be made or bought. They are red, blue and yellow.

Secondary Colors: Green, purple and orange. They are called secondary because they can be made by mixing pairs of the primary colors.

Color Wheel: A circular presentation of primary, secondary and some intermediate colors in the same sequence found with a prism. This places complements opposite and harmonious colors adjacent to one another.

Complementary Color: The hue directly opposite another on the color wheel. Also called *contrasting* or *conflicting* color, it produces two distinctly opposing effects, depending on how it's used. If we mix one with its complement, it will gray that color. For instance, blue with a little of its complement (orange) mixed in will produce a gray/blue. If we mix in enough of the orange, a neutral gray can result.

If, on the other hand, we lay the two colors side by side, each will appear brighter than when separate.

Harmonious Colors: Two colors close in hue; adjacent colors in the color wheel. Examples are red and orange, yellow and green, green and blue.

 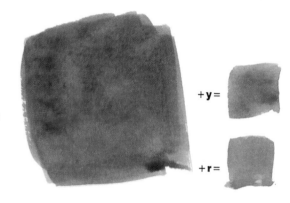

Orange mixed with black produces brown. A small amount of black produces a bright brown; a greater amount, a grayer brown. Varying amounts of red, yellow and black with orange in the mixture will produce any brown imaginable.

Where's Brown?

Brown is an important color since so many things in nature are, or could be, brown—yet it doesn't appear on the color wheel! Still, to design with it we must establish colors that are its complement and harmony.

Here's an easy way to do it that you won't forget: *orange mixed with black produces brown*. Although there are several other color combinations that will produce brown, think of brown only as orange with black in it. A small amount of black produces a bright brown, a greater amount a grayer brown. A red/orange produces a red/brown like burnt sienna; a yellow/orange produces a yellow/brown like raw umber. Varying the red, yellow (orange) and black in the mixture will produce any brown imaginable.

As a practical matter you probably wouldn't go through all this trouble to produce a brown; you would just buy a couple of browns

and put them in your palette as do most artists. However, the foregoing bit of information will help you remember brown is orange with some black in it.

This being true, put brown where orange is in the color wheel. Now you see that brown—like orange— is a warm color; its complement is blue, and its harmonies are red and yellow—as indeed they are. Simple.

How About Black?

Know how to make half the hands go up in any painting workshop? Ask how many have been told not to put black in their palette.

I don't know where this originated, but nothing bad will happen to you if you put black in your palette. On the other hand, you'll suffer no harm if you *don't* have it. But the point is black is a handy color; it can make life easier for you—provided you use it correctly. In fact, Rembrandt called it "the queen of colors."

First, don't use black to paint a black area. Instead, you're far ahead of the game if you mix two colors to get it. The reason is you'll need some variation in your black to provide interest—either by lifting out a lighter part or scraping some lighter shape or line into it—if the black area is of any size at all. If you've mixed two colors, the variety of those two will show in these lighter areas, while the "tube" black will have the same boring gray in all of these lighter spots.

Do use the black to produce grays by mixing water with it (or white if you're painting in oil or another opaque medium). The more water in the mixture, the lighter the gray. If you need a warm gray, any warm color in the mixture will do it. Any cool in the mixture will produce a cool gray.

Black can also be used to "gray down" or dull the intensity of a bright color. True, this can be done by adding a little of the comple-

ment, but black is just as effective and requires no thinking or searching the color wheel for the complement. For dulling color, you might say black is the complement for all colors!

Black is also useful in taking any color down to its last, darkest values of three and two. Value one, of course, *is* black. Most colors are around value four or five as they lie in your palette, and can be made those values in your painting by using all pigment and very little water. The last two value steps can be created only by mixing another darker color with it, like brown or black.

If you decide to use black in your palette, use *ivory black*. Lampblack is made from soot, and, if too much is used in mixtures, can easily give your painting an overall dirty, "sooty" appearance.

And How About White?

White comes in a tube if you paint in oil or another opaque medium. It is the white paper if you're painting in transparent watercolor.

In transparent watercolor this white paper is probably more important than any color. Ed Whitney called it the "trump card," to be played prominently and carefully. By that he meant that the white areas of your painting are attractive, so you wouldn't want to leave them out or shape them poorly. The contrast between the other painted areas and the white paper is also an important factor in making your painting appear fresh and crisp.

Women are generally more sensitive to color than men. Ten times as many men as women are color blind.

What's Your Favorite Color?

All of us react to color according to our psychological makeup and past experiences. For a painter, it might be advantageous to know which colors, in general, are preferred by most people and which are not.

Here is a brief summary of conclusions of psychologists and other investigators after experiments with thousands of people:

1. The warm colors (red, orange, yellow) are positive and aggressive, while the cool colors (purple, blue, blue/green) are negative, aloof and serene.

2. Pure color preference, in the order named, is:
 a. Red
 b. Blue
 c. Violet (blue/purple)
 d. Green
 e. Orange
 f. Yellow

3. Red is preferred by women; blue is more popular with men.

4. Women are generally more sensitive to color than men. (Also, ten times as many men as women are color blind.)

5. Most people prefer bright colors in small areas.

6. Most people prefer grayed or light colors in large areas.

Purple, the royal color, was a favorite of ancient kings.

7. Color combinations are preferred in the following order:
 a. Contrasting (complementary) colors
 b. Harmonious (analogous) colors
 c. Monochromatic (various values of one color) colors

After reading "Color Balance" in chapter seven, numbers five and six will be no surprise to you since both cases are illustrations of color balance in chroma. Number seven proves contrast is more interesting than harmony, which is more interesting than variations of one color — but all are attractive!

Creating a Mood

Color can be used to *transmit an emotion or create a mood*. "Stage three painting" is what I've called it elsewhere. In fact, using hue to indicate one's disposition or mood is common in our language. We might say, "He saw red" to describe a person in a fit of anger. Melancholy moods are portrayed in a type of music called "blues." A coward is described as "yellow." We become "green" with envy, while a "black mood" denotes despair, and a "gray personality" labels a drab friend.

Historically, color has been associated with various offices, institutions and symbols, and can be used to create a mood in paintings.

Yellow, for instance, is a sacred color in China and Western Christianity, where gold leaf designs are used as backgrounds for paintings and on altars to signify light and divine glory.

Bright, clear, high-key yellow is symbolic of the sun and is associated with cheerfulness and gaiety.

The darker, grayer and greenish yellows, on the other hand, are the most disliked. They are associated with illness, deceit, indecency, cowardice, envy and treachery.

Red has the strongest chroma and greatest powers of attraction. It is positive, aggressive and exciting.

Gray/green can suggest the unnatural and unhealthy.

In fact, red light has been found to elevate the pulse and raise blood pressure, while blue light has the opposite effect on us. Red is the first color designated by name in primitive languages and is the color most used in primitive art. Yellow and red have been described as "the colors of the crowd."

So it's not surprising red symbolizes the primitive in us, and is associated with rage, stress, danger, courage, virility and sex. The Roman battle flags were red, as are those of anarchists and terrorists today, as a symbol of violence. The "red light district" and "scarlet woman" are allusions to red's sexual properties.

Use red with caution. It's an alarming color, and a little goes a long way. Too large of an area easily becomes fatiguing.

Purple traditionally has been used to describe that which is stately, rich, pompous and impressive. It's the color of royalty and was favored by the ancient kings.

Violet, or blue/purple, is cool, negative and retiring. It has a melancholy character, suggesting resignation; it's similar to blue, but more solemn.

Oswald Spengler, in his *Decline of the West* says, "Violet, a red succumbing to blue, is the color of women no longer fruitful and of priests living in celibacy."

Blue is cool, serene and tranquil. "Enchanting nothingness," Goethe called it. An atmospheric color, it transmits the feeling of space and distance. It's also an aloof color and has been used in the past to denote spirituality and nobility.

Green psychologically transmits feelings similar to blue. More neutral (it is neither warm nor cool) and passive than blue, it is considered the most restful of colors. The green olive branch is the symbol of peace, and the green laurel wreath, of immortality.

Middle green also expresses freshness—raw, inexperienced youth and immaturity—while yellow/green is the color of fresh, new growth. A grayed blue/green in moonlit areas of a night scene is normal and restful. However, the same color used as the color of one's skin expresses the opposite: something macabre, unnatural and unhealthy.

While black, white and gray—technically speaking—are not colors, they *are* as a practical matter for an artist, and are capable of producing psychological responses as well.

White, a positive, luminous, airy and delicate color, is associated with purity, innocence and truth. In the old western films, the "good guys" wore white hats. And in medieval tales, the knight in shining armor rode a white horse.

Black—a depressing, solemn and profound color—signifies sorrow, gloom and death. When we mourn, we don black robes. Black is also indicative of mystery, terror and evil, probably because of an early childhood fear of darkness that persists for some adults. "The Prince of Darkness" typifies this color association.

On the other hand, when black is used as a background for white, gray

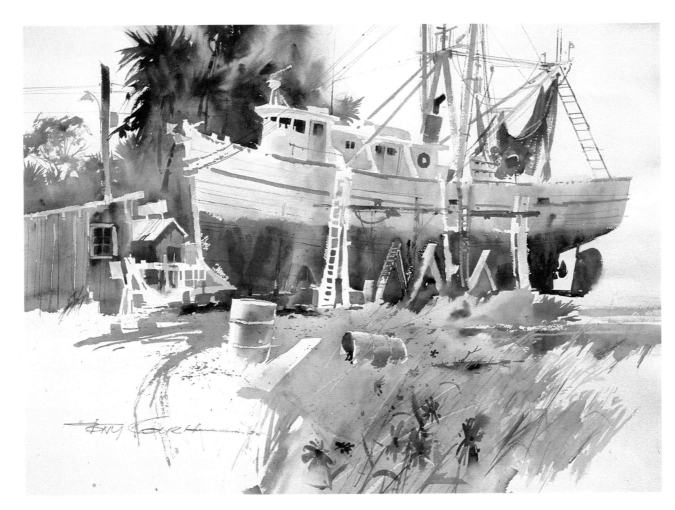

Ship Shape
22 × 30

When you are planning a painting, ask yourself, "What do I want to say and what is the best way to say it?" Pick colors that best express your ideas. In this painting, I wanted to describe a busy boat yard, so I used bright warm colors and sharp value contrast to suggest this mood.

or color, it produces a smart, conservative elegance or formality. Witness the tuxedo and the commencement ceremony's cap and gown.

Middle Gray—a combination of white and black—is more mellow than white, and lighter and less somber than black. It is usually associated with sedate old age, resignation and humility.

Generally preferred to either black or white, middle gray is the ideal background for bright color since any color will appear brighter by contrast. This is particularly true if the gray is tinged with the complement of that color.

Then how can we use this information to create a mood with our paintings? Simple as it seems, the key is to first *plan to create a mood*. The artist who never thinks of this as he paints will, of course, only create a mood by accident.

Now, which colors would you use to paint a bustling metropolitan street scene with its noisy traffic and scurrying pedestrians? Without being told, you probably know the painting had better be dominantly warm: reds, yellows, orange and red/browns. It should have red since, like the traffic and the people, it's an aggressive, virile color. Still, red must be used with constraint because of its fatiguing quality. The painting is all about action and conflict, so there should be some contrasting cools (blue/greens to fight the reds?).

There ought to be as much bright color as possible to give the illusion of excitement, without making the painting gaudy (out-of-balance toward bright). The painting also would need all the contrast in value we can muster, so we'd have a few very dark colors against very light.

Similarly, bright warm color and sharp value contrast were used to describe a busy boat yard in *Ship Shape*, see page 45.

Now how about a painting of a wake or a funeral? Would you make this painting dominantly warm or cool? Cool, of course. Which cools? Violet (blue/purple) would be a good one, since it is negative and retiring, with a melancholy character, as we discovered earlier. I would use a little blue/green, too, with blue and gray for variety. Of course, for good design, there would have to be a few contrasting warms.

You probably know this would be a low-key painting. That is, it would have a dominance of darks, and the chroma would be weak (no bright colors).

How effective is this practice of using color to create a mood? It can best be illustrated by mentally reversing the color schemes for the two scenes just described. Now imagine what they would look like and how convincing they would or would not be as a busy street scene and as a wake, and I think you'll get the idea.

Cools, of course say snow and ice better than warms. So a snow scene would be dominantly blues, blue/gray, blue/purple and blue/green for objects that would otherwise be green, saving the few contrasting warms for those objects normally warm: tree trunks, buildings, clothing, etc., as in *Eagan's Place*, see page 47.

Often painters, enamored of a striking cast of yellow or pink on white snow from a low sun, will put too much of this into the painting and kill the illusion of cold that a blue dominance provides. These warm highlights are just as effective when kept to a minimum with a maximum of cast shadows to keep the dominance cool.

Ed Whitney, when beginning a demonstration painting, used to say to the class "What do I want to say?" then, "What's the best way to say it?" Ask yourself those two key questions as you plan your painting. Next, select those colors that say it best. See if your paintings aren't enhanced.

Eagan's Place
22 × 30

A cool dominance is appropriate for a winter scene because it says snow better than a warm dominance. A snow scene, then, should have a dominance of blues, blue/greens, blue/grays, and blue/purples. I included a few warm colors in this painting for contrast.

Imagine that the color schemes for this painting and *Ship Shape* were reversed. Would these paintings be as effective?

Stroll
22 × 30

CHAPTER SIX
Value

What are values and how are they used? As we saw in the beginning of chapter five, value is the lightness or darkness of any hue. Every hue has the same range of values, from lightest value to darkest.

While the human eye may be able to discern a wide range of values for a given hue, most artists reduce them to ten easily seen steps in value, illustrated in a numbered scale of one to ten. Value one is the darkest (black, in fact) rising in number and lightness to value ten, which is the lightest value (white).

Hue first becomes apparent at value two. A very dark, dull color becomes increasingly lighter and brighter until the mid-values of three, four and five, at which most colors exist in the palette. Then they become less bright again as they rise to the lighter values, arriving at ten where all hue is gone again and only white remains. The exceptions are yellow, yellow/green and orange, which are very light colors. Yellow in the palette is about value nine and yellow/green and orange are about value seven.

The artist's perpetual job, then, is to start with these *home values* of three, four and five and make them either lighter, darker or leave them at their home value.

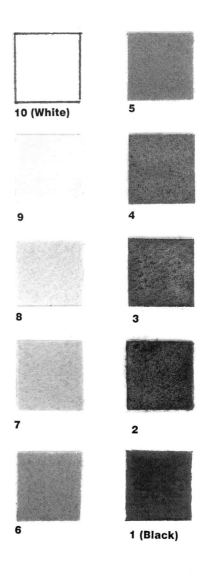

10 (White) 5

9 4

8 3

7 2

6 1 (Black)

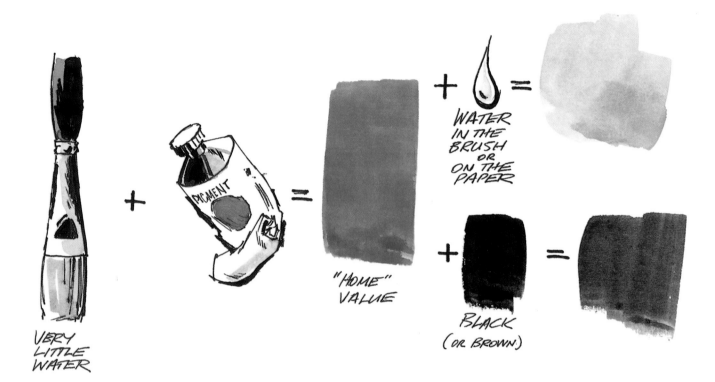

VERY
LITTLE
WATER

"HOME"
VALUE

WATER
IN THE
BRUSH
OR
ON THE
PAPER

BLACK
(OR BROWN.)

Make hues lighter by mixing in water or white paint. Leave them at home value by using straight pigment. Make them darker by adding black or brown and very little water or white.

You can make hues lighter by mixing in water (white paint if painting in oil or opaque watercolor). Leave them at home value by using straight pigment and very little water or white. Make them darker by adding black or brown and very little water or white. To make brown darker than it is, add blue or black and very little water or white.

Four patches of ultramarine are shown here and each has a different value. See if you can match them yourself. If you can't, practice until you can do it easily. If you can do it with blue, you can do it with any color and it'll make adjusting values in a painting much easier for you. *Hint:* I used a little black with ultramarine to get the last patch.

Now that we know what values are and how to get them in any hue, let's apply the principles of design to them.

Value Gradation
Gradation is the *gradual* change from something to something else. In this case, it's the gradual change from a dark color to a lighter one or vice versa.

Gradation is a marvelous tool. I can't recommend it heartily enough in *any* size area, but particularly in large places like sky and foregrounds. Gradation always makes an area infinitely more entertaining.

Getting gradation with oil paints is just a matter of careful blending with a brush. It takes a little more finesse with watercolor. I began the

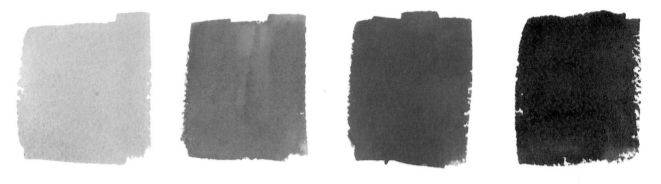

Patches of ultramarine are shown here, each a different value. See if you can match them yourself.

watercolor wash, bottom right, by wetting the whole area with clean water. I painted from the top with all pigment and no water. As I worked down, I overlapped the previous stroke without getting any more pigment.

When I finished the watercolor wash, I made adjustments, keeping the whole thing wet. I darkened some areas by adding pigment. I lightened other areas by picking up pigment and water with a "thirsty" brush, working back and forth until I had a smooth gradation.

Practice this until you can do it easily. It pays huge dividends in your painting. Remember, the pros all use this technique; the amateurs avoid it.

Value Balance

In chapter seven we'll learn how the design principle *balance* can be used to make our audience comfortable with our painting. We'll also learn how our design can be balanced in all seven elements: size, shape, line, direction, color, value and texture.

We will see color has three dimensions: *hue*, *value* and *chroma*. All three of these dimensions should be balanced when balancing color.

Most artists don't have a great deal of trouble balancing a painting in *hue*; we just have to make the painting dominantly warm (but not *all* warm) or dominantly cool (but not *all* cool).

Most have little trouble balancing a painting in *chroma*; it merely shouldn't be too bright or too dull.

Balancing a painting's *values*, however, doesn't come as easily. To most painters, values and where to put them in a design are such gray areas (pardon the pun) that ignoring them altogether is common. Yet no single element is more effective for producing a comfortable, interesting painting than a proper use of values. It's the very "life blood" of a successful design.

This "gray area" needn't be. An artist doesn't need to understand

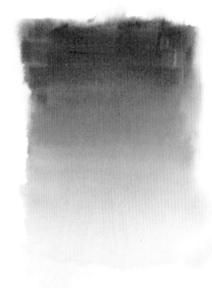

If you are a watercolorist, you should practice making graded washes until you can do it easily.

A

B

Squint your eyes at the swatches above until the hues disappear. See how *A* merges while *B* remains separate.

the "hows and whys" of color balance in value; it's enough to merely pick a value pattern and use it.

Similarly, you don't have to know of, or even think about, the remaining principles of design using value if you'll again just use any one of the value patterns that follow. Everything will fall into place automatically so that the principles are followed. This is the very purpose of the "patterns."

The Value Patterns

There are twelve value patterns that I know of. An artist only needs to know *one* to produce an effective design, but the more of them you know, the greater your selection and the easier it is to find one suitable to your subject matter. Not every subject lends itself readily to every pattern.

Beyond proper value design, a value pattern largely insures no two overlapping shapes will be the same value, which could produce an ambiguous area.

Squint your eyes until the hue almost disappears (simulating distance) and see how *A* merges while *B* remains separated. Remember hue won't separate shapes; *value* does it.

The Big Four (+ Two)

Several years ago Edgar Whitney analyzed about a hundred paintings by some of the Old Masters and contemporary painters with established reputations and found the values of all the works would fit into one of six broad value patterns. Two of them are very specialized and

1

4

3

6

5

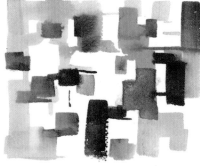

2

The Basic Value Patterns

probably of limited use to you, so I'll only cover them briefly.

Pattern five, called simply "gradation," is rarely used. It is nothing but a gradual change in value from light to dark, across the width of the painting.

Pattern six, called "Even Surface Tension" or "Checkerboard Animation" among other titles, was made popular by the "West Coast School" a few years back. It is a system of small overlapping shapes, alternately pitting lights, darks and mid-values against one another. At the same time, cools are placed against warms, and the total effect is a bright, exciting painting.

One problem with the pattern is the lack of a dominant shape, but this can be overcome by making one shape larger than the rest, as Frank Webb does in his painting shown on page 54.

The remaining four patterns are the ones I use most often. In all four, the largest area—which is a field that extends from top to bottom and from side to side, is a mid-value. In all four patterns, a dark or light shape is placed upon this mid-value field. Neither the dark nor light shape should be as large as the mid-value field, but it should be big enough to be important, easily seen from twenty feet away. A shape that is 25-35 percent of the total painting area would probably accomplish this.

In two of the patterns, three and four, a small shape of opposite value is placed either *inside* or *overlapping* the larger shape. In three there is a small light shape inside the larger

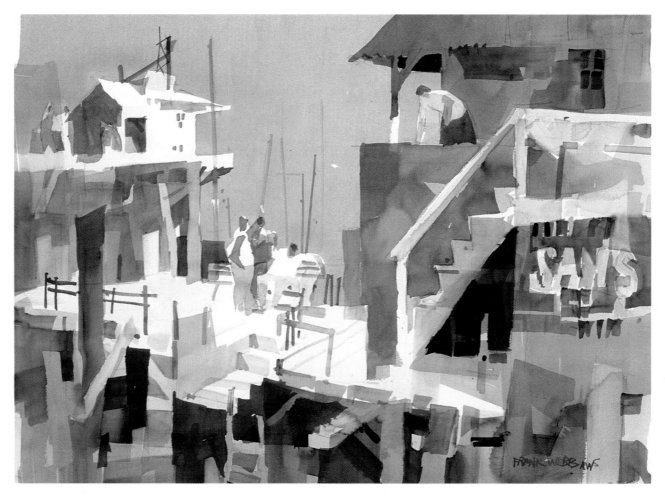

Sam's Place, Monterey
by Frank Webb
22 × 30

In this painting by Frank Webb, we see how a lively, exciting painting can be created by using a system of small overlapping shapes, alternately pitting lights against darks and cool colors against warms.

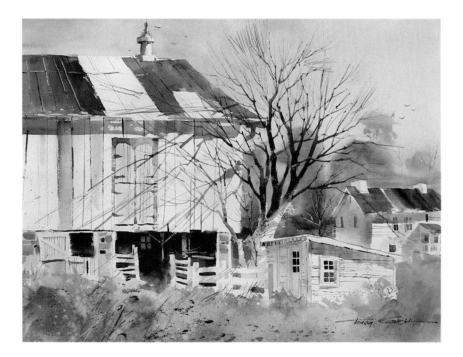

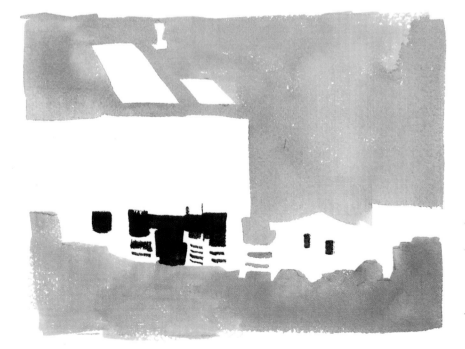

In the painting *Early June*, right, look at the light shape in the simplified value abstract and the corresponding light shape in the painting. Even though this shape in the painting is dominantly light, there are several dark and mid-value areas in it. Otherwise the painting would be a poster like the abstract. In the same manner, the darks and mid-values have other values in them. Many successful paintings have been done using only two values as shown in patterns one and two.

dark shape, and in four there is a small dark shape in a light shape.

It's important that these light and dark shapes *touch* in some manner, so the smaller shape must either be inside the larger shape or overlap it.

The value of the larger, mid-value field is also important. If the 25-35 percent shape is dark, then the mid-value field should be a light mid-value so this dark shape will be easily seen. Conversely, if the 25-35 percent shape is light, the mid-value field should be a dark mid-value.

Bear in mind when I write "light," "dark" and "mid-value," I don't mean shapes of only one value as happens in a poster. I mean a light, dark and mid-value *range*. A "light shape" will be a shape of various light values—even a few dark and mid-value spots—but *dominantly* it will be a light shape. Similarly, mid-value and dark shapes will be only *dominantly* mid-value and dark.

In the painting *Early June*, look at the light shape in the simplified value abstract and the corresponding light shape in the painting. Even

Winter's Cover
22 × 30

Winter's Cover is done with pattern one—a large dark shape in a mid-value. Notice the mid-value is a very light mid, so the dark shape will "pop out." Notice also that the mid-value includes anything that isn't dark, so it extends into the lights (even white). The value pattern abstract and the black-and-white photo will help you see these values.

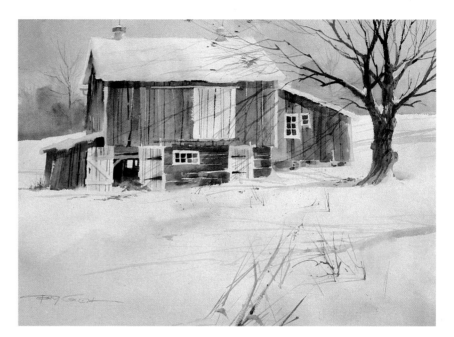

though this shape in the painting is dominantly light, there are several dark and mid-value areas in it. Otherwise the painting would be a poster—like the abstract. In the same manner, the darks and mid-values have other values in them.

Many successful paintings have been done using only two values, as shown in patterns one and two.

Winter's Cover is done with pattern one, a large, dark shape in a mid-value. Notice the mid-value is a very light mid, so the dark shape will "pop out." Notice also the mid-value includes anything that isn't dark, so it extends into the lights, even white. The value pattern abstract and the black-and-white photo will help you see these values.

Beaver Falls, a painting with pattern two, has a large light shape in a mid-value. Again we're dealing with two values: a light shape and "everything else." The "everything else" is anything that isn't light, so it's a mid-value that extends into dark, even black, in some areas.

P.O. Box is a pattern three painting. It has a small, light shape inside a larger dark, which is in an overall mid-value. I use this pattern most often. Notice the light shape is in-

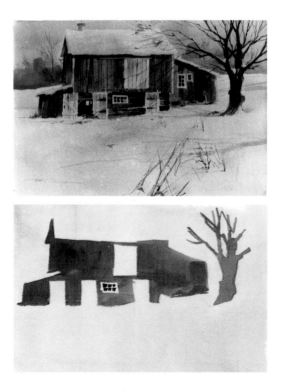

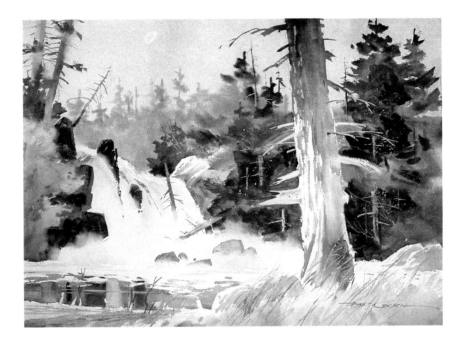

Beaver Falls
22 × 30

Here is *Beaver Falls*, a painting with pattern two—a large light shape in a mid-value. Again we're dealing with two values: a light shape and "everything else." The "everything else" is anything that isn't light, so it's a mid-value that extends into dark, even black, in some areas.

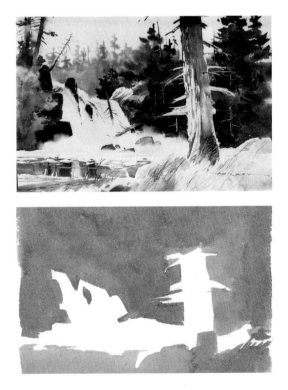

side the dark, providing maximum value contrast there. This is a great place for the center of interest, since this value contrast directs the eye right to that spot—an advantage of this value pattern.

You can see the mid-value is a light mid to make the dark shape more readable. It is also worth noting that the mid-value, dark and light areas are not the same size. The mid-value is the largest area, as it must be in any pattern. Next in size is the dark shape, with the light shape smallest.

In *Granny's House*, you see a painting using pattern four. It has a small dark shape (with a few small repeats) inside a larger light shape, which is in an overall mid-value. The mid-value, as usual, covers the largest area, but it is now a dark mid-value to make the light shape stand out. The dark and light shapes are a reverse of pattern three.

These four patterns cover 95 percent of my paintings. Occasionally, I'll produce a composition of shapes and lines that defies classification into any of these four patterns. That is, it's difficult to find a pattern that will fit the composition without extensive juggling of shapes.

If it's a landscape or seascape, I call on another group of six value

P.O. Box
22 × 30

Here is *P.O. Box*, a pattern three painting —
a small light shape inside a larger dark,
which is in an overall mid-value. I use this
pattern most often. Notice the light shape is
inside the dark, providing maximum value
contrast there. This is a great place for the
center of interest, since this value contrast
directs the eye right to that spot — an advan-
tage of this value pattern.

You can see the mid-value is a light mid
to make the dark shape more readable. It is
also worth noting that the mid-value, dark
and light areas are not the same size. The
mid-value is the largest area, as it must be
in any pattern. Next in size is the dark
shape, with the light shape smallest.

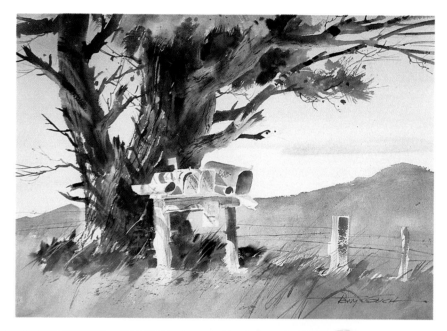

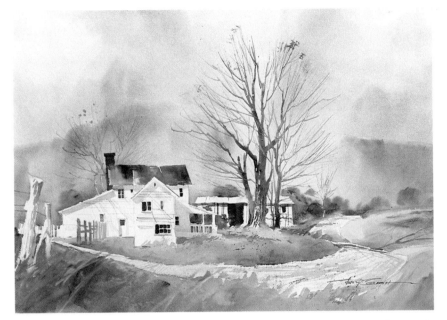

Granny's House
22 × 30

Here's *Granny's House*, a painting using pattern four. It has a small dark shape (with a few small repeats) inside a larger light shape, which is in an overall mid-value. The mid-value, as usual, covers the largest area, but it is now a dark mid-value to make the light shape stand out. The dark and light shapes are a reverse of pattern three.

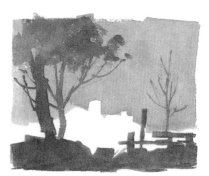
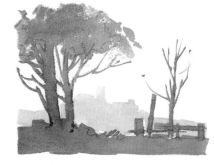

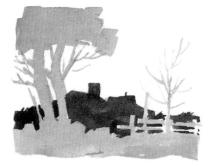
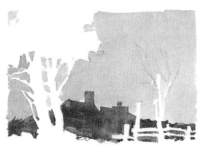

patterns that have been used by many artists. Usually one of these will fit. I call them my "emergency patterns" and use them when nothing else will work.

Emergency Value Patterns

For these patterns, the artist separates the painting into a foreground, middle ground and background. Then he assigns a value *range* to each of these "grounds." For instance, the foreground might be dominantly dark, the middle ground light, and the background in the mid-value range. Or the values of any of these "grounds" might be interchanged. There are six possible value patterns for the same painting, shown here in diagram form.

Of course, like the previous four patterns, each ground is *dominantly* dark, light or mid-value as opposed to *exclusively*, as these diagrams might indicate. In a foreground of mid-value, for example, there will be small spots of light and darks but dominantly the foreground will be mid-value.

In *Autumn at Eagan's*, a painting done using the value pattern in the top left of the emergency pattern diagrams, there is a dark foreground, light middle ground and mid-value background. The black-and-white photo will help you see it.

You can see it again in *Eagan's Place*, on page 47: same value pattern, same subject, except now it's winter.

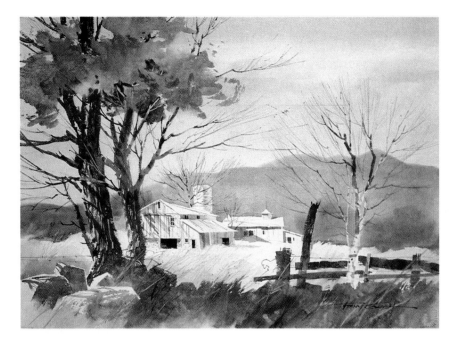

Autumn at Eagan's
22×30

This painting was done using one of the emergency value patterns. It has a dark foreground, light middle ground and mid-value background. The black-and-white photo will help you see it.

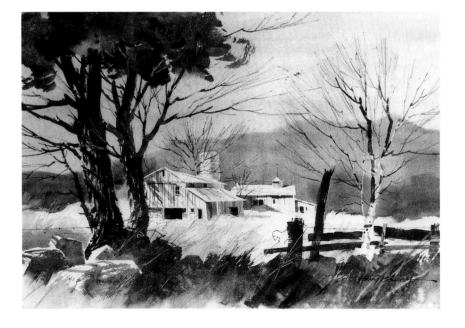

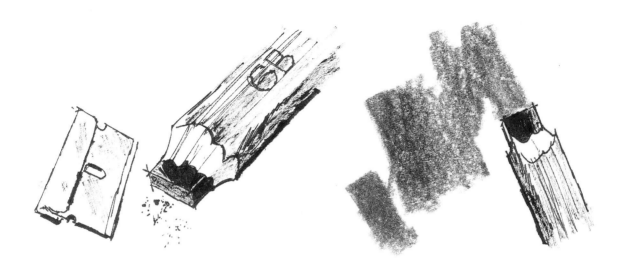

I like to use a soft 6B carpenter's pencil sharpened to a chisel edge for my rough value sketches.

How I Pick a Value Pattern

There is, of course, no one way to pick a value pattern for a painting. A system that might work for me likely won't be as useful to you, and it could be totally useless to some-one else. Still, it might help, in gen-eral, if you know how I do it.

The first step in any painting is to scan subject matter — either while wandering around on location or by thumbing through sketches done during previous wanderings. I look for that combination of shapes, shadows, even colors and values that will spark an idea for a design.

Sometimes the composition and value pattern will arrive at the same time. I might find a combination of a tree, low bush and a cast shadow that could be a handsome dark shape. And looking in another di-rection, I could see an interesting combination of rocks with a cast shadow upon them that I could put into the dark shape to form a

smaller light shape. Everything else would be mid-value. Bingo! There's my composition and I'll say it with value pattern three! They arrived simultaneously.

Other times I'll build a composi-tion of shapes and lines with no value pattern apparent and then study it, looking for a value pattern into which it might fit.

I guess you would have to say I'm mentally suspending each of value patterns one, two, three and four over the composition to see which will fit with the least amount of ad-justing. Sometimes shapes will have to be moved or adjusted in size to make it work.

This thinking process is done not entirely mentally; I usually do it with a series of small, postcard-size rough value sketches. There is little detail — only silhouettes of major shapes are blocked in with a light, middle or dark value.

I like to use a soft 6B carpenter

Right are two examples of my rough value sketches. I spend only about five minutes on each, playing with making the shapes different values until I am satisfied with one.

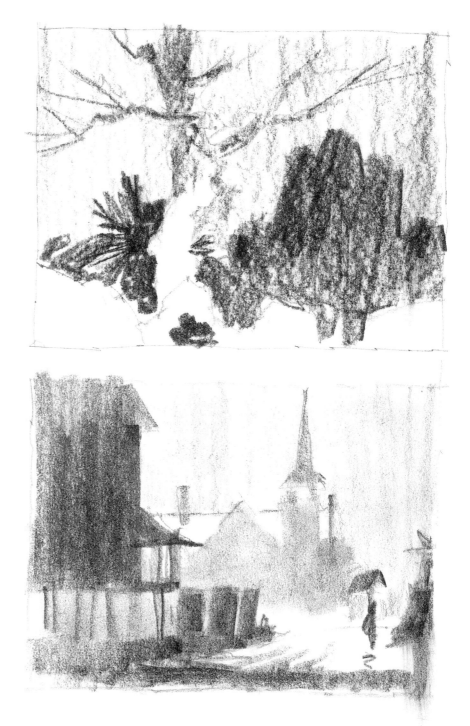

pencil sharpened to a chisel edge because I can cover large areas rapidly with it. Bearing down gives me a dark shape, lightening up a bit produces a mid-value, and I usually leave the light shape white paper.

Looking at a sketch before I've put in the values, I know the value of any shape or object can be a light, middle or dark value regardless of what it is in real life, just by painting it a value.

A building, for instance, is dark, light or mid-value, depending upon the color the builder painted it. This is further modified by the position of the sun. It will be light when sunlit, and mid-value or dark when backlit or in the shadows. The same is true with trees, animals, people — anything. So working with light, middle and dark values, I toy with making the shapes in my sketch various values.

I spend only five minutes or so on each study, and generally I have something acceptable within the first two. If not, I'll keep thinking and "value sketching" until I've done five or six. At that point, enough is enough. I want to spend time painting, not just value sketching, so I'll pick the best of the bunch and paint that one.

**Eleanor's
Barn**
22 × 30

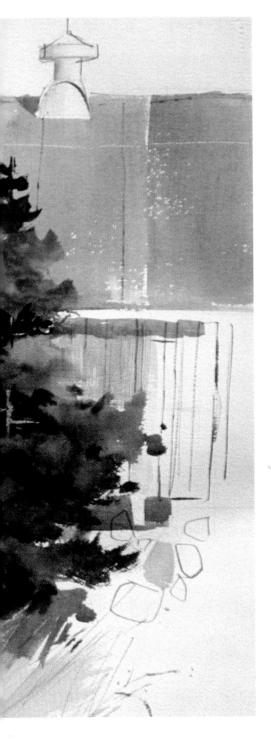

CHAPTER SEVEN
Balance

Balance is visual comfort. The lack of balance in any of the elements—particularly in shape—makes us uncomfortable with the painting, just as surely as balance makes us feel "at home" with it.

There are two types of balance, usually termed formal and informal.

Formal Balance of Shapes

Formal balance can be described as the static placement of shapes around a central axis. If you can divide a painting in two so that one side is almost a mirror image of the other, you have formal balance. This even distribution of shapes is also called symmetrical balance, and it is almost always organized around a vertical axis.

Although useful in creating a stable, somber mood—even dignity—formal balance is not the most attractive form. Formal balance lacks variety in the size of shapes themselves and in the size of the intervals between the shapes. The stability and regularity of formal balance can also be visually boring.

Informal Balance of Shapes

Informal balance is a much more attractive way of balancing size and shapes. It can best be illustrated with a seesaw.

If two children, one large and one small, sit equidistant from the center of a seesaw, it would be off-balance. But if the larger of the two moves toward the center, the seesaw will balance. Similarly, a large shape can be balanced by one smaller by placing the larger near (but not in) the center of the design while the smaller is placed near the edge.

You may have seen or heard this same principle compared with a steelyard scale. One is illustrated on page 66. No need for confusion here; if the seesaw is suspended, rather than supported by a fulcrum, the principle is the same.

When balancing shapes, it's helpful to know a dark shape appears heavier than a shape of light value, so a small dark shape will balance a larger light shape. Also, it's not necessary to balance one shape with another—a dark *area* will work as well as a dark shape.

In *Guide*, see page 67, the large shapes of the trees and lighthouse are balanced by the small dark island shape and dark area of the sky in the upper right.

Color Balance

While bright billboards, circus posters and magazine covers successfully yell for our attention, we soon tire of their appearance. Why is that? Probably because the human condition is such that noise, conflict and excitement—although at first interesting—soon become tiring.

Yet these same advertising media would provoke *instant* boredom—meriting no notice at all from us—if they were blank white, black, gray or some dull, low-chroma color.

The artist's problem is avoiding both of these extremes. In a design the goal is initial attraction, yet pro-

ducing a color combination the viewer can "live with" so his attention remains on the painting.

The answer lies in color balance. No surprise here; we continually strive for proper balance in all areas of our lives: balanced diet, balanced exercise, balanced budget, etc. We are most happy, or content, with balance.

The bright circus posters, billboards and magazine covers become tiring because their color is out of balance—toward brightness. The others merit no attention because they are out of balance in the other direction: too dull.

A complete study of color balance is a wide, deep exercise that is too large for this book. (It involves journeys into such diverse disciplines as optics, aesthetics and mathematical proportions.) For our purposes it's enough to understand that color has three dimensions—hue, chroma and value—and in a broad way we may say that color balances at neutral gray in each of these dimensions.

Hue Balance

The human mind wants to see *hues* and their complements in a painting in such proportion that, if the hues could be mixed, they would produce a neutral gray.

Value Balance

Light, mid- and dark *values* mixed in such amount that they would produce a mid-value (number five) gray create value balance.

A

An even placement of shapes around a central axis, as in *A*, is an example of formal balance.

B

An irregular distribution of shapes is called informal balance, as in *B*.

C

Informal balance is best illustrated by a seesaw. If two children, one large and one small, sit equidistant from the center of a

D

seesaw, it will be off balance, as in *C*. But if the larger of the two moves toward the center, it will balance, as in *D*.

E

The same principle can be illustrated with a steelyard scale. One is illustrated in *E* and *F*. A steelyard scale is the seesaw sus-

F

pended, rather than supported by a fulcrum, and it works the same way.

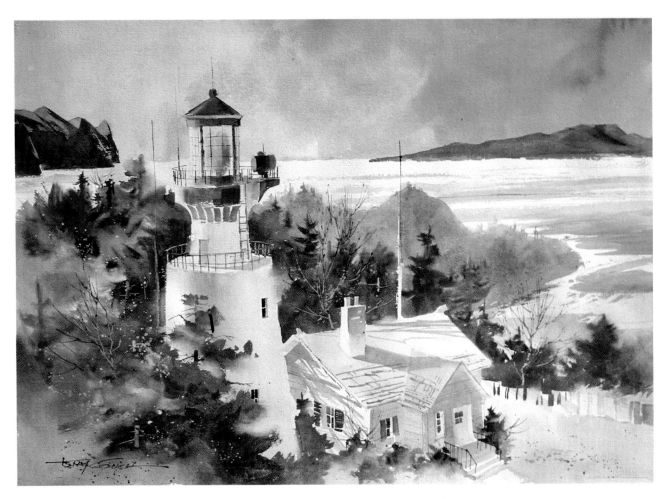

Guide
22×30
In the collection of Dale Luecke

In this painting, the large shapes of the
trees and lighthouse are balanced by the
small, dark island shape and the dark area
of the sky in the upper right.

A painting can be balanced by putting equal shapes on either side, or by placing them in the middle. Either results in a rather boring arrangement because they lack variation. In the example at right, a dark area in the upper corner is used to balance the lighter shapes on the right.

Chroma Balance

Color brightness and dullness in sufficient amount that, when mixed, would produce a mid-range *chroma*. That is, midway between strongest chroma and no chroma at all (black, white or gray).

A successful design then, is a balance of warm and cool, dark and light, bright and dull color. Of course these colors will never be mixed in a painting, but the human mind makes a judgment of this when viewing a painting and is happiest with a balance at neutral, mid-value gray.

While it's impractical to scientifically measure these units every time we paint, it helps to be aware of them so we know what we're trying to accomplish as we paint. As a practical matter, here are a few sim-

ple guides that will force us into the same results.

1. Balance in hue: The complement of any hue is the one opposite from it on the color wheel or the hue on either side of it. For this reason any warm is the complement of any cool, and mixing them will produce a gray.

Although there will be warms and cools in the painting, and one or the other should be dominant, their rough sum should be a neutral gray.

2. For balance in value, simply use one of the value patterns covered in chapter six.

3. Strong chroma fatigues the eyes . . . and so does weak chroma. The general law for chroma balance is: the brighter the color, the smaller

A brilliant spot of bright red will balance a larger field of grayed blue/green. The law for chroma balance is: the brighter the color, the smaller its area must be; the greater the area, the weaker the color must be.

its area must be; the greater the area, the weaker the color must be. A moderate amount of bright color is balanced by a larger amount of grayer color; a brilliant spot of bright red will balance a larger field of grayed blue/green.

A Practical Approach to Color Balance

Now that we understand enough of the theory of color balance, here's how I put up with it as I paint. First, I do a value sketch. In this I decide where the major shapes will go and which will be in the light value range, which will be in the dark range, and which in the mid-value range. I place these according to a *value pattern* (see chapter six, "Value"), which insures a balance of value.

Next, I shoot for a color dominance. I'm not trying to make any one particular color dominant, rather, I aim for a dominance of warms or cools, depending on which present the subject matter most effectively. A desert scene, such as *On the Rocks*, see page 70, would surely have a warm dominance, and a snow-bound landscape would likely have a cool dominance.

I do this with a rough mental plan for the large areas (which will be warm or cool) before I start, then while painting I constantly step back and appraise how the painting is going. If I am after a warm dominance and the painting so far is cool or barely warm in dominance, more warm goes into the painting. If I see I have an overwhelming warm dominance, more cool colors will go in. I

don't pay attention to a particular warm or cool color; any warm or cool will do.

Before painting *On the Rocks*, for example, I made a mental note to paint the mountain, terrain and rocks mostly warm so a cool sky wouldn't compromise the warm dominance I wanted the painting to have.

I gray down these warms and cools somewhat in the body of the painting (nothing in nature is as bright as the pigment in the palette), but I find excuses to make things brighter around the center of interest. This not only helps direct attention to this center of interest, but it helps balance the duller chroma colors in the body of the painting.

This way of working *generally* re-

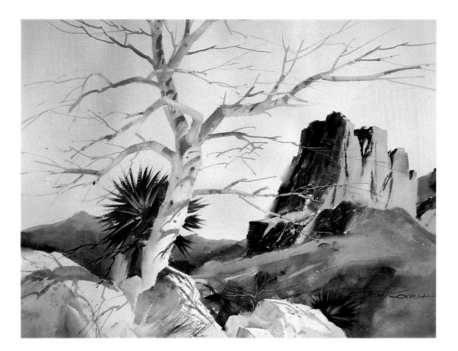

On the Rocks
22 × 30

In this painting a warm dominance was appropriate for the subject matter. Before I began painting, I made a rough mental plan for the large areas (which will be warm), then while painting I constantly stepped back to judge how the painting was going. I made the mountain, terrain and rocks mostly warm so that a cool sky wouldn't compromise my warm dominance for the painting.

sults in a near balance of hue, value and chroma at completion of the painting. The last step, however, is to prop up the painting, *step back* and analyze the overall result, including color balance. If it appears to be too gaudy (out of balance toward bright), I'll gray down a few passages with either a glaze of the complement or a neutral gray (same result). If instead the painting appears too gray, I'll place a spot or two of bright color around the center of interest to balance it.

If a painting of warm dominance appears too warm, then your senses are probably telling you there is not enough contrasting cool color in it. If it were all mixed together, the result would be a warm gray rather than neutral. The solution is to add more cool somewhere in the paint-

ing. The reverse, of course, is true for a work that is too cool.

You might be thinking that a simple way to achieve balance in hue is to provide equal amounts of warm and cool; surely this would result in a neutral gray mixture. True enough, but this would be formal balance. And as we saw at the beginning of this chapter, informal balance is more interesting.

So a better balance of hue would be informal, effected with more warm if a warm dominance is desired or more cool for a cool dominance. The balance is achieved with the opposite color in a smaller area by using maximum temperature hues there. For instance, a large area of browns and yellows would be balanced by a smaller area of bright, cold blue.

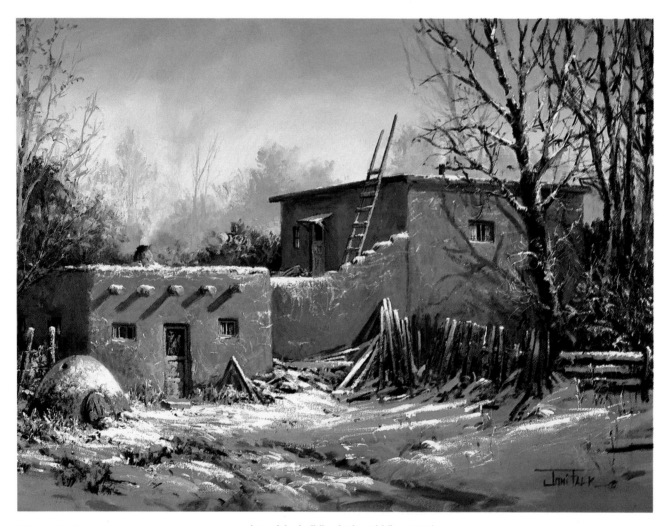

Winter Light
by Joni Falk

This painting by Joni Falk is a good example of color balance. It is a winter scene, and the dominant color temperature is cool. The sky, background trees and foreground are all painted with cool colors. However, the cool colors are balanced by the warm colors of the building in the middle ground.

Incidentally, the contrast of the warm colors of the building against the cool background focuses your attention on it, making the dwelling the center of interest. Notice how the patch of white snow draws the eye to the doorway on the left, which acts as the focal point of the design.

CHAPTER EIGHT
Harmony

Harmony is the repetition of any of the seven elements—size, shape, line, direction, color, value or texture—with only a slight change. An example of harmony in color, for instance, would be blue and blue/green. These colors are different, but still related.

Harmony lies between the two extremes of monotony and discord. We have three choices when repeating units in a design: We can repeat them with no change at all, with a little change, or with a great deal of change.

If we repeat them with no change, the design is apt to be boring. If we repeat them with great change, we use the principle of contrast or gradation. If we repeat them with little change, we employ the principle of harmony.

It's interesting that aside from harmony, three other principles—variation, contrast and gradation—also deal with change. That's half of the total list of eight. It might give you some indication of how important change is for successful design.

Whereas variation, contrast and gradation may provide change from one extreme to the other (large to small, warm to cool, dark to light), harmony is a quiet, subtle, slight change and useful as a change of pace in areas of violent contrast.

Like the other principles of good design, harmony can be applied to all the elements.

Rather than paint a large passage the same color, we might provide some entertainment without a change in temperature by dropping in a little of a harmonious color.

This large yellow area, for example, with a spot of orange or yellow/green would still be warm, but more entertaining.

A round shape and an oval are harmonious shapes.

A straight line and a slightly curved line are harmonious.

To balance the colors of the dominant temperature in a painting, include some of the colors of the opposite temperature.

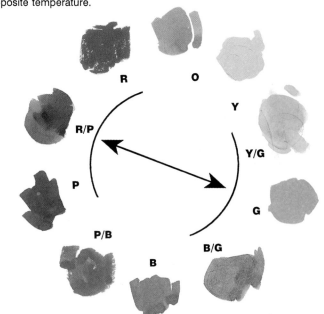

Shape Harmony

Two shapes that are different but similar in construction would be harmonious. For instance, a round shape and an oval are harmonious. A painting with many angular shapes would have shape harmony. Harmony is a useful thing to keep in mind when thinking about the principle of dominance as well.

Size Harmony

A group of shapes close in size but not identical would be harmonious in size. A row of fishing boats in a harbor would be similar in size, but no two would be exactly alike.

Line Harmony

A straight line and one slightly curved would be harmonious. Think of the siding of an old barn. Most of the lines would be straight, but a few gentle curves, suggesting the effects of weathering over time, would be an example of line harmony.

Value Harmony

Just as colors from the same area of the color wheel are harmonious, so too are values from the same area of the ten-value scale. I'm talking about a range of values. For instance, the values close to white make up a range of harmonious light values. Those close to black form a dark range.

Harmony of Subject Matter

There is also harmony of subject matter to consider, for instance, a sailor and a ship or a bottle and a cork. An example of harmony of subject matter with literary symbolism would be a dove and an olive branch.

Color Harmony

The principle of harmony is very useful when thinking about color. Color harmony involves the idea of balance and variety, and it is most easily illustrated by looking at the color wheel introduced in chapter five.

Following the principles of dominance and unity, a painting should have either a cool dominance or a warm dominance. For instance, if you decided that a warm dominance would be appropriate for your subject matter, you would include those colors that are close together on the

warm side of the color wheel. However, if a painting had only warm colors or only cool colors, it would certainly have dominance and unity, but it would be boring.

To balance the colors of the dominant temperature in a painting, you should include some of the colors from the opposite side of the color wheel. Let's say you are painting a picture of a red barn in the middle of autumn foliage. Obviously, a warm dominance would best suit your painting's color scheme. Look at the color wheel, and you can see that you will include colors on either side of red, including oranges, yellow/oranges and red/purples. To provide balance and variety, you should include some cool colors as we discussed in the last chapter.

However, you wouldn't want to use a bright green to balance the red of the barn because that would be a distracting, discordant note. Instead, you want to balance your painting with colors that are still cool colors, but closer to the warm side of your color wheel. Look again at your color wheel, and you will see that yellow/greens and blue/purples fit the bill nicely. Notice that these colors form a kind of triangle with red, the central color of your related warm colors.

You can use this idea for any color scheme for a painting. First, determine the dominant color temperature. Then determine what colors are on the opposite side of the color wheel, and move a step or two on either side toward the dominant color. If you were painting a snow scene with a cool dominance, and blue/purple was in the middle of the range of cool colors you were using, red/purple and blue/green would be good colors to use as accents. Including touches of these colors would create an interesting variety and still maintain color harmony.

Color harmony also works in a painting with a large passage that needs to be kept warm or cool because more of the contrasting color would be too much. Rather than paint the whole area the same color, we might provide some entertainment without a change in temperature by dropping in a little of a harmonious color. So a large yellow area, for example, with a spot of orange or yellow/green would still be warm, but more entertaining. Blue with touches of purple and blue/green would produce a more interesting cool area.

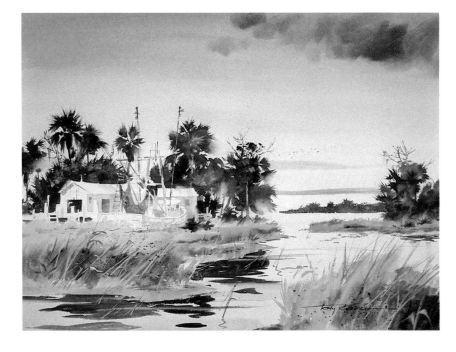

Break of Dawn
22 × 30

In this painting, the line of scrub palmetto and palmetto palm trees behind the fishing shacks are dominantly dark yellow/green, as this is the characteristic color of that foliage. But for variation I've used spots of the harmonies on either side of yellow/green: yellow, orange (brown) and blue/green.

The yellow low sky is varied but kept warm with a faint trace of a very light value red/orange, a harmony of yellow.

The grayed yellow marsh grass in the foreground is kept warm but varied with areas of harmonious orange and brown (brown is grayed-down orange).

Nova Scotia Inlet

22 × 30

Harmony is the repetition of any of the seven elements, with only a slight change. In *Nova Scotia Inlet*, the grass areas are yellow/brown, with a few harmonious orange and yellow/green areas. The angular buildings are echoed in the harmonious angular rocks.

Evening Light

by William Hook

30 × 40

One of the reasons this sweeping landscape is an entertaining unit is William Hook's delightful use of harmonies, which offer enough change to keep us interested without taking us too far away from the whole. It's hard to miss the similarity of curved shapes first in the clouds, then again in the cliffs, and yet again in the foreground clumps of brush—harmony of shape! The varied, yet harmonious cools and darker mid-values found in the sky, distant shaded bluffs and foreground shadowed brush make the sunlit, warm cliffs explode with contrast.

Used with permission of William Hook.

Wyoming Winter
by Joni Falk
10 × 20
oil

This fine painting by Joni Falk is easily seen as a unit due in part to the large sections of a flat snow field that is echoed in the harmonious shaped and colored clouds in the upper left. Also, the angular shape of the open water in the foreground is repeated in the harmonious angular shaped cluster of teepees in the middle. Noteworthy also are the harmonious oranges, browns, yellows and yellow/greens that contrast with the dominance or harmonious cool colors.

The Patterns of September
by Foster Caddell
24 × 30
oil

One of the factors that makes *Patterns of September* an entertaining unit is the piece of blue/green in the sky that harmonizes with the purples and blue/purples in the rest of the painting. Another subtle change of color—thus entertainment—is seen in the yellow/green of the sunlit field that harmonizes with the bluer greens in the shadowed areas. The harmonious shapes of the clouds and foliage make great contrast for the lone angular shape of the barn.

**Knee
Deep**
22×30

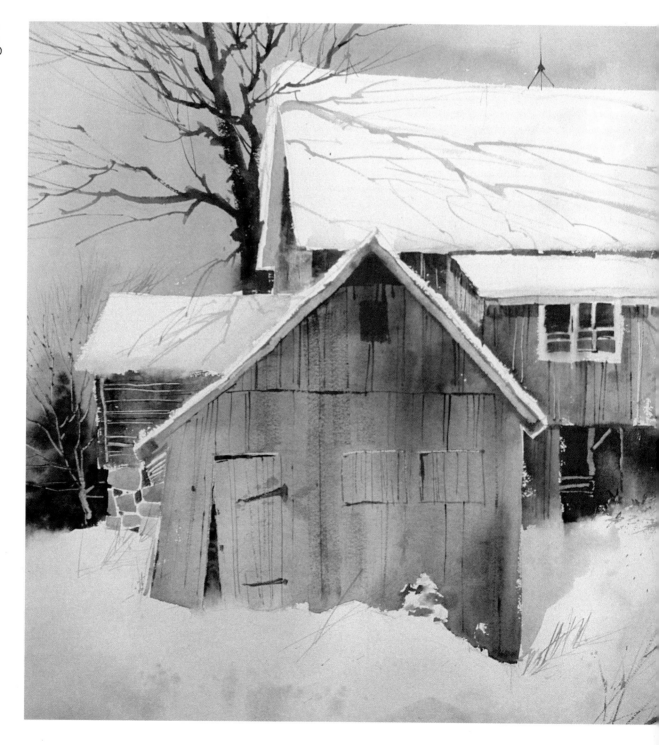

Gradation & Contrast

G radation and contrast are similar in that they both produce entertainment through change from one extreme to the other, but they differ in the manner in which they accomplish it.

Contrast

Contrast is an abrupt change from alpha to omega. For instance, a sudden change in color from a warm to a cool on the side of a barn is contrast. This jarring move is extremely attractive, but it easily becomes tiring, so it must be used with constraint—a little goes a long way.

Gradation

Gradation, or gradual change, is a natural phenomenon and is part of our everyday life: Every day we see darkness *gradually* turn to light with the dawn. The sun *gradually* ascends the eastern sky, then *gradually* descends into the west. The sky is a *gradual* change of value and color from the light green/blue near the horizon to a *gradually* warmer, bluer and darker sky directly overhead. With the sunset, daylight *gradually* turns to darkness. Seasons *gradually* change from fall to winter to spring to summer. We *gradually* grow in size, wisdom (hopefully) and age.

Color Gradation

Since we live with gradation we are at home with it, which makes it a marvelous design tool. In art it means the *gradual* change from one element to another—color, in this case. Interestingly, it's a combination of harmony and contrast. In the process of changing from one color to its contrasting color, it must go through the harmonious colors in between!

Using gradation to go from one color to its complement or from warm to cool nets precisely the same result as contrast, but with an advantage. While contrast provides a "jarring" change, gradation does it in a more soothing, natural manner, since it is a *gradual*, harmonious trip to the complement. For this reason, gradation can be used everywhere with no limits, while abrupt contrast must be used carefully to avoid creating a disturbing work.

Although gradation is useful in large areas, I heartily recommend it in an area of any size, down to the smallest tree trunk or distant building. It instantly makes that area infinitely more attractive.

There's no magic in the warms and cools I used; any warm against any cool would do the job. Perhaps I used the same pair too often here.

Gradation in color and value is also a technique that separates accomplished painters from the rookies. I don't understand why since the principle is simple and relatively easy to execute.

Color Contrast (Conflict)

It's true that one could easily produce a color or temperature dominance in any design by using only one color or colors of only one temperature (warm or cool), but we would pay the price of boredom. For the sake of entertainment, there *must* be some contrasting

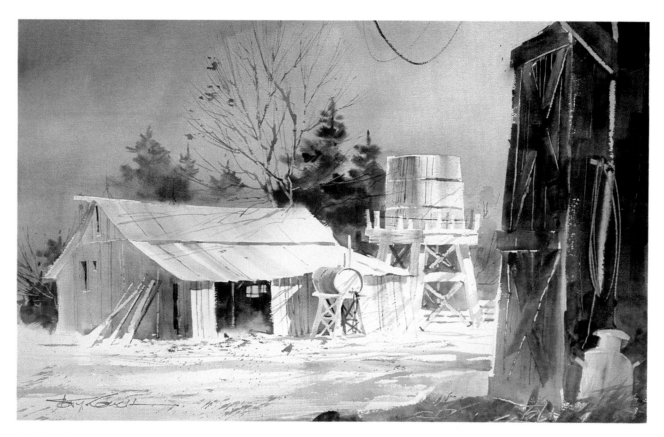

Looking Out
22 × 30

In *Looking Out*, an otherwise uneventful sky is made more interesting with a simple gradual change from warm on the right to cool on the left. It's done again in a smaller area—the left side of the light barn is warm on the left and cool on the right. You see it again on the shaded left side of the water tank, which is cool at the top and warm at the bottom. Even the small oil drum on the scaffold has a gradual change from cool at the top to warm at the bottom. Look for other areas of temperature gradation.

color or a little of the other temperature.

Any color's contrasting color, as we learned earlier, is the one directly opposite from it on the color wheel *or* it is the color on either side of that contrasting color. For this reason, almost any warm is the complement of almost any cool. In fact, when I paint, I take advantage of this fact, rather than go through the mental gymnastics of figuring which color is the complement of which, I merely think "warm" and "cool." Ninety percent of the time I come up with a complement, and I'm close enough in the other 10 percent.

Remember when using contrast in color or any other element, a little goes a long way. Too many areas of abrupt contrast, particularly in color, will make your design disturbing.

Value Gradation
Value gradation is the gradual change in value across a shape or large area. Like gradation in color, it's a marvelous tool and produces spectacular results whenever and wherever it's used. Unlike contrast, there's no limit to its use, since we're so comfortable with gradual change.

We saw earlier that gradation is

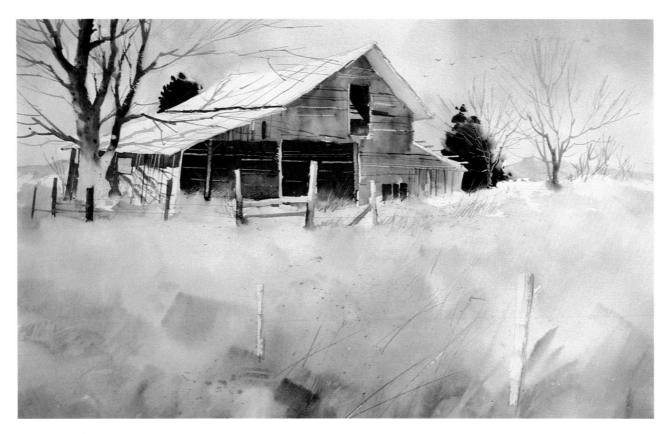

particularly useful in large, otherwise uneventful places, such as a sky or foreground. Often it's all that is needed to entertain in an area, and that's good news to the novice painter having trouble deciding what to put into the foreground. In fact in *Waco Palace*, above, all there is in that large foreground is gradation—dark up close and lighter in the distance!

Only incidently did I also squeegee out a pair of faint fence posts and scrape and paint in a few weeds. The foreground could stand on its own with gradation alone.

As long as we're looking at *Waco Palace*, notice also the gradation in value in the tree on the left and under the eve of the barn. In both cases it's light at the bottom, gradually darker at the top. This lends not only entertainment, but shows the effect of sunlight bouncing off the ground. This really happens in bright sunlight; I only exaggerate it here.

I don't mean to leave the impression that gradation should be either in color or value. Both could, and often do, happen at once. Look again at *Looking Out* on page 80. While the sky changes in color there is also a gradual change in value, light on the right and darker on the left. Squint your eyes a little if you

Waco Palace
22 × 30

Gradation is particularly useful in large, otherwise uneventful places, such as a sky or foreground. In *Waco Palace*, all there is in that large foreground is gradation—dark up close and lighter in the distance. Often it's all that is needed to entertain in an area. That's good to remember when you are having trouble deciding what to put into the foreground.

Here is an example of gradation in shape. There is a progression from curved rock forms on the left to angular on the right.

don't see it right away. The same happens on the left side of the barn and in the water tower; warmer/lighter gradually becomes cooler/darker.

Although gradation could be applied to every element, I use it mostly for hue and value.

Value Contrast

While value gradation is a gradual change from light to dark, value contrast is a more abrupt, attention-getting change, and it is vital to the life of your painting.

By simply following any value pattern covered in chapter six, ample value contrast is automatically arranged.

Gradation in Shape

Gradation in shape is the gradual change from one shape to another. For instance, a series of curved shapes gradually become angular in the rocks of the painting, above.

Contrast in Shape

Contrast in shape is the abrupt change between angular, curved or rectangular shapes. The diagram, top right, shows the abrupt change between the angular spaceship and the round planet.

Gradation in Size

Gradation in size is a gradual change in size of a group of shapes from large to small, or vice versa. The most effective way of creating the illusion of depth is the gradual change in size of like objects—large in the foreground, increasingly smaller as they go back into the distance.

Look at *Transition* on page 100 and notice the gradual change in size of the rocks, from large in the foreground to smaller in the distance. Note the illusion of depth it produces. The same is true for the trees.

Contrast in Size

Contrast in size is an abrupt change in size. It is a powerful tool for creating interest and promoting drama or telling a story, as in the giant whale and tiny ship, bottom right. See this idea again with the great difference in size of the two barns in *Looking Out* on page 80.

Gradation in Direction

Gradation in direction is the other powerful tool for creating depth. It's not just a handy tool for entertaining in an area; it can take the eye directly to the center of interest, or it can just give the illusion of depth in any painting. In *Light in the Window*, see page 84, the road gradually changes direction from the left foreground to the right foreground, then back to the left and away, which leads us to the house with the light in the window.

This is an example of contrast in shape. The very angular spaceship on the left contrasts with the round shape of the planet on the right.

Dramatic contrast in size creates interest.

Light in the Window
22 × 30

Notice the contrasting thick and thin lines in the tree twigs and branches, as well as the cracks between the siding on the building on the left in the painting.

Sunday
22 × 30

You can find many examples of both gradation and contrast in this painting. Notice how the fence in the foreground is light on the left, where it contrasts with the building behind it and the weeds and grass. Gradually it gets darker until it contrasts with the lighter background on the right.

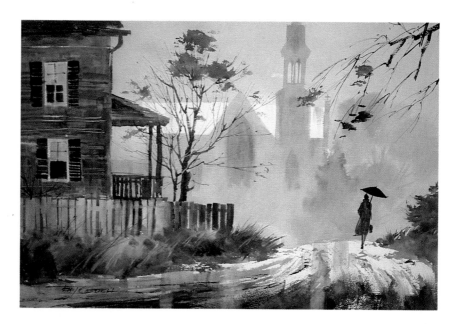

Contrast and Gradation in Line

A thick line contrasts with a thin line, as does a light line with a dark line or a long line with a short line. The same changes produced *gradually* are just as entertaining and constitute gradation. A thick line gradually becoming thin, a dark line gradually becoming light, and a series of lines of various length in order of length are examples of gradation in line.

Notice the contrasting thick and thin lines in the tree twigs and branches as well as the cracks between the siding on the building on the left in *Light in the Window*. Look for the same thick/thin lines in the same places in any painting in this book. I don't think you'll be disappointed. It's not an accident; it's designed entertainment!

An example of contrast and gradation of line might be the shadows cast upon a roof by its cedar shakes, thick/thin lines of gradually increasing interval. *Rainy Day* on page 1 is a fair example of this.

The Dorothy C
22 × 30

Notice how the contrasts in this painting make it interesting and entertaining for the eye. The dark pilings on the far left contrast with the boat and the dock in the middleground as well as with the lighthouse in the background. The gradation in value from foreground to background is a good example of how value gradation creates depth and atmosphere.

Just a Powder
22 × 30

CHAPTER TEN
Alternation & Variation

Both alternation and variation are forms of repetition. They are two separate ways of repeating a series of sizes, shapes, lines, directions, colors, values or textures.

Alternation

Alternation is seldom, if ever, used in painting; more often it's used in decorative design, such as textiles and wallpaper. It's a system of alternating between two or more types of the same element. For instance, a thick line might be alternated with three thin lines.

This type of repetition is common for carpet, drapes, etc., but not practical for painting pictures. We can eliminate this one from our inventory of painting tricks.

Variation

Repetition with *variation* is a great design tool, however. In fact, it's at the very heart of design since de-

sign's purpose is visual entertainment. That is to say, we're in the entertainment business, and that's what entertainment is: change, or variation.

As I noted earlier in chapter eight, four of the principles of design—contrast, gradation, harmony and variation—have to do with this very thing. Only the degree and method of execution differ. *Contrast* is a fast, abrupt change from alpha to omega. *Gradation* is the same change, but in a slow, gradual manner. *Harmony* is only a small change from alpha to beta, let's say. *Variation* is all of these wrapped into one!

Ed Whitney used to counsel against covering more than three inches of the painting without varying the color in some way, in any size painting. We can change it to something darker, lighter, another color or a combination. We can do it abruptly or with gradation.

Similarly, Whitney would advise

Alternation between similar elements, such as three thin lines alternating with one thick line, is used in decorative art, but not in painting because it would be boring.

1

2

3

When painting a group of trees, we have three choices:

1. Repeat them with no variation at all (as in painting number one) so they are the same size, shape, color and value—and so the interval between them is the same. This is the most boring approach possible.

2. Repeat them with alternation (as in painting number two). This is better suited to decorative design.

3. Repeat them with variation (as in painting number three), that is, with variation in width, height, shape, color, value and intervals between them. This is the most entertaining presentation.

not to use the same texture everywhere at the edge of a shape without varying it someplace with another texture.

In short, variation means changing everything we can get our hands on however we can (abruptly, gradually, with great or small changes) and varying the interval between them.

In *Downstream*, notice the variation in shape: round silo versus rectangular buildings; rounded banks of snow versus jagged, angular breaks in the ice in the frozen stream. Notice the variation in the size of the

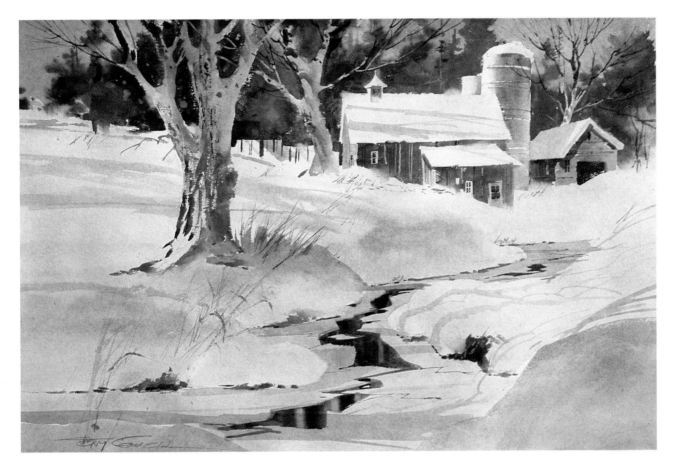

buildings, trees, boards in the fence, cast shadows, etc., and the intervals between them. Notice the variation in line: the straight and curved lines of the twigs and branches in the trees, the straight lines of the buildings, the curved lines of the silo, and the variety of thickness and length of these lines and the interval between them. Notice the variation in direction: the oblique shadows, stream, limbs and branches, fence, vertical tree trunks, fence boards, barn siding, silo and the horizontal buildings. Notice the variation of color in the snow: warms and cools (mostly cool); in the background trees: many colors but dominantly dark green; in the two big trees: cool at the top and warm at the bottom; and the warm buildings and cool silo. Notice the variation in value in the sky: darker at the left, gradually lighter on the right; in the three largest trees: dark at the tops and light at the bottoms; dark trees, building and sky and light snow. Notice the variation in texture: rough, hard and soft in the tree trunks and limbs; rough and hard buildings; soft distant trees, sky and snow; smooth stream.

Downstream
22 × 30

Variation means changing elements in size, shape, direction, color, value, texture and the interval between them. See how many instances of variation you can find in this painting.

Canyon Juniper
22 × 30

Notice how the clumps of leaves on the tree vary in size and shape and how they are separated by intervals of different dimension.

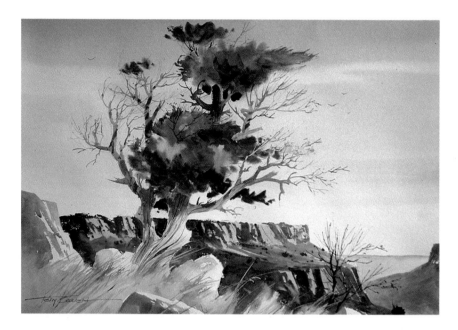

Trout Stream
22 × 30

Look at how the trees vary in color, direction, size and texture. Even the distances between the twigs and branches show great variation.

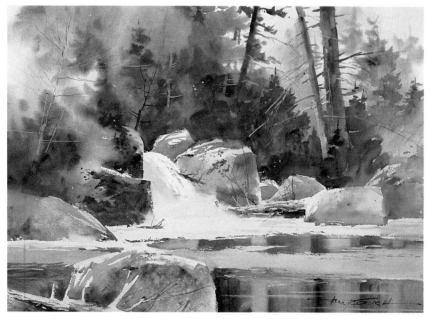

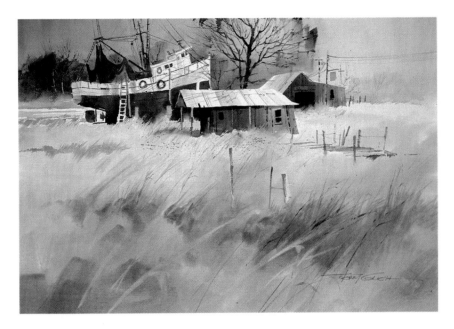

Shadetree Mechanics
22 × 30

This painting is a fair example of variation in interval. None of the distances between shapes, and the shapes and edges of the painting, are the same. Notice particularly the interval between fence posts, boards and tree limbs.

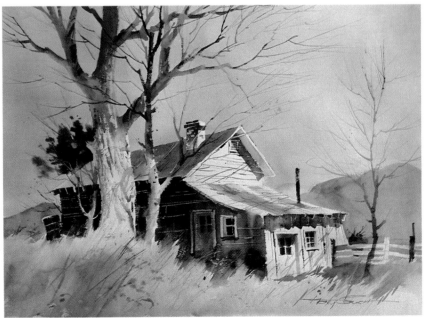

Settler
22 × 30

Ed Whitney recommended never painting more than three inches of a painting without changing something. Notice how the colors are varied in almost every area of *Settler*; for example, the change in color of the shadow under the eave on the left.

Every one of these paintings is filled with examples of how variation makes a picture more interesting.

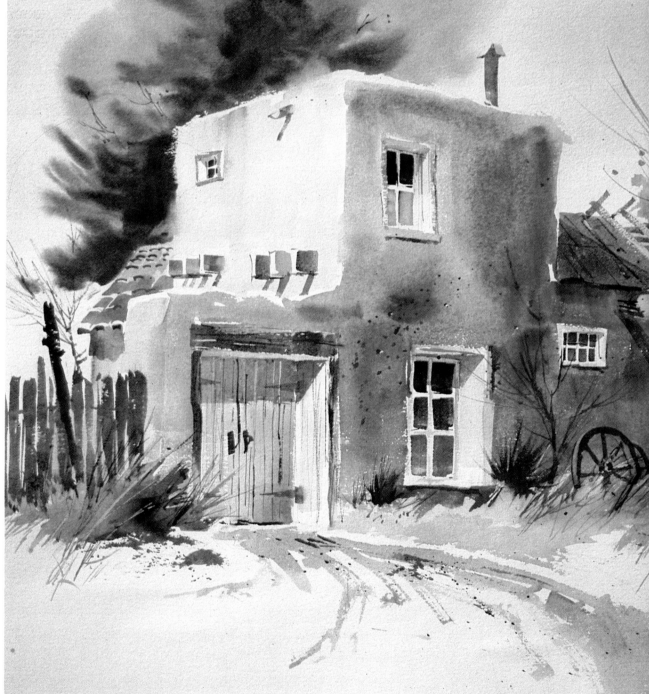

Mi Casa
22 × 30

CHAPTER ELEVEN
Dominance & Unity

Deep in our makeup is a desire for dominance. In any unit we look for that which is more important than the rest; it is a form of order for us. The absence of it means chaos, like a pile of junk. If everything is the same, we have no reference points, no beginning or end, a lack of order.

Quite naturally, when faced with a new task, we form an order of priorities. We establish what is critical and what is not. Then among the critical, we decide what is *most* important, then next most important, and so on.

When first hearing of a political group or movement, we immediately wonder, "Who is the leader?" When we come upon inefficiency or chaos in a group, don't we always ask, "Who's in charge here?" Why do we do these things? Because we have a basic need for unity and order, which in art is synonymous with dominance.

So we seek dominance in our art. If there are several shapes, we look for one to dominate the rest. Several colors? One should be more important than the rest. Although not necessary, it is possible to create a dominance in each of the seven elements in the same painting. Most audiences are comfortable with a dominance among three or four elements.

How to Make an Element Dominant

There are four ways to make any one shape, color or other element dominant over others in a design.

1. *Make it happen more often than any other.* In a design of several shapes, if one type of shape appears more often than any other, we see it as the most important, or dominant, type of shape.

Similarly, if straight lines should be dominant, there should be more straight lines than curved. If soft texture should be dominant, there should be more of that texture than hard or rough. The same is true for all of the elements.

2. *Make it larger than anything else.* In a design of several shapes, the largest of the group is the dominant shape. A word of caution here: A little larger won't do it. The dominant shape must be quite a bit larger than the rest, so that it still appears larger than other shapes when seen from a distance.

This applies to *all* of the elements. For example, to make the mid-values dominant in a painting, they should cover the largest area. The same is true for a dominant color, and so on.

3. *Make it brighter than anything else.* In a design of shapes of weak (grayed) chroma that are close to the same size, a bright shape will be more easily seen, thus it will be the dominant shape. The same is true for line and texture.

4. *Provide more value contrast there than anywhere else.* In a design with shapes of light value that are close to the same size, a very dark shape will be more easily seen, thus it will be the dominant shape. The same is true for line and texture.

Shapes three and five are curved, but all of the rest are angular, giving the whole string an angular dominance.

Which shape seems most important to you? Of course, it's the middle shape, because it is the largest.

Which shape jumps out, even at a glance? It's the bright shape, and that makes it dominant.

Which shape do you see first at a fast glance? It's the dark one, because there is more value contrast there than in any of the others. In fact, the others are hardly noticeable, and that makes the dark one the dominant shape.

Any one of these devices might be used, or any combination of them, including *all four* if necessary to make an element dominant.

Color Dominance

Although your painting will have more character if you can arrange a dominance of one color, at the very least it should have a dominance of temperature. That is, the painting should be dominantly warm or dominantly cool.

Producing a color, or a color temperature dominance, is most easily done by making the total area of the painting with that color or temperature larger than any other. For instance, if I want my painting to be dominantly warm, I'll have more warm colors in the painting than cool. Similarly, if I'm trying for a blue dominance, you will see more blue in it than any other color. *Cypress* is dominantly a warm yellow/green for this reason.

When working for a color dominance, it helps to know that although red, orange (and brown), yellow and yellow/green are warm,

Cypress
22 × 30

This painting is a good example of how dominance can be used to create unity. A warm yellow/green is the dominant color. The dominant direction is horizontal because of the painting's horizontal format, the row of background trees and the foreground bush, and the waves in the water. The dominant type of shape is a general-

ized tree shape. Among these, the large cypress on the left is the dominant shape, because it is the largest and it has the greatest contrast around it.

Notice how the stump on the right balances the cypress and helps frame the fishermen, the focal point of the picture. The eye is gently directed to that spot by pointers included in the composition.

they're not equally warm. Red and red/orange are the warmest, while yellow/green is the least warm. So when analyzing my painting that I want to be dominantly warm, if I find I have no dominance and very little additional area of the painting that can logically be warm, I add a small spot of "hot" red or red/orange rather than one of the less warm colors.

Similarly, blue is cooler than purple or blue/green, so I would use blue if the situation were reversed.

BEST

OK

NEVER!

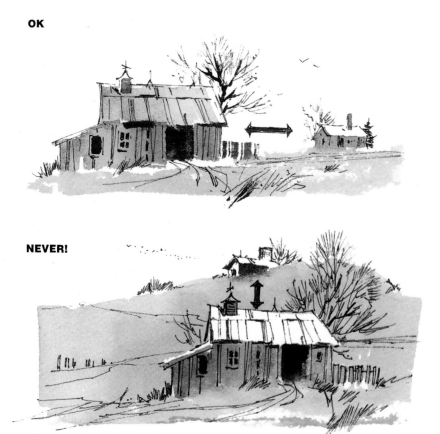

Two same or similar elements should never be placed directly above or below one another. They may be placed horizontally across from each other, but the most effective place is oblique to the first element.

The *shape dominance* of *Cypress* is the tree shape, since there's more of those than any other shape. Within the tree shapes, there is one dominant shape: the large cypress on the left. It is dominant because it's the largest tree and there is more value contrast around it than anywhere else.

The *line dominance* is straight. The only curved lines are the draped fishing line on the smaller trunk in the right foreground.

The *direction dominance* is horizontal, thanks to the horizontal row of background trees and the foreground brush, the waves in the water, and the horizontal format of the painting. Although there are verticals, the greater number of horizontals provides the dominance.

The *value dominance*, as in all my paintings, is mid-value, since it covers the greatest area.

I wish I could point out a *texture dominance* for you in *Cypress*, but I don't see one. It seems there is about as much soft texture as hard and rough. Although the painting would have more "character" with it, the dominance in the other elements is enough to make this a successful work.

Unity

No matter what else we do, the painting should appear as a unit when it is finished. That is, any one part of the painting should resemble the whole.

As usual, Ed Whitney said it best, "If you tear your painting into four equal parts and throw them into a pile of other paintings similarly di-

vided, and anyone can then instantly pick out the four that are your painting, your painting is a unit."

For this reason one should be careful not to place one line, direction, value, texture, color or color temperature in only one area of the painting, it could easily make the painting appear fragmented, or disjointed. For the sake of unity, if it is easily seen it must be repeated or echoed someplace else. "Nothing should happen only once" is the way others have often put it.

The "someplace else" is important. Two same or similar elements should never be *directly above or below* one another. They might be placed *horizontally* across from each other if no other place can be found to repeat it, but the most effective place is any place *oblique* to the first element.

For instance, the dark green water in *Valley Stream*, right, is a reflection of the dark hill and distant tree above it, but it's close enough in value and hue to be a nice oblique repeat of the large foreground firs in the upper right. The distant trees are almost horizontal to the firs, but are low enough to be an oblique repeat of them. The grayed brown/green of the foreground grass is repeated obliquely in the middle ground valley.

Just to the right of the snow-covered peak I have a faint horizontal repeat with another peak. It would have been better if I could have made it oblique, but horizontal was the only logical place for it.

Valley Stream
22 × 30

This painting is a good example of echoing elements that establish unity. It helps to remember the idea that "nothing should happen only once." The dark green water reflects the dark hill and distant tree above it, but it's close enough in value and hue to be a nice oblique repeat of the large foreground firs in the upper right. The distant trees are low enough to be an oblique repeat of these same firs. The grayed brown/green of the foreground grass is repeated obliquely in the middle ground valley.

Shapes are also echoed. Just to the right of the snow-covered peak I have a faint horizontal repeat with another peak. It would have been better if I could have made it oblique, but horizontal was the only logical place for it.

Split Falls
22 × 30

Repetition with variation creates interest,
while dominance gives a picture unity. No-
tice how no one line, direction, value, tex-
ture or color occurs in only one place in this
painting.

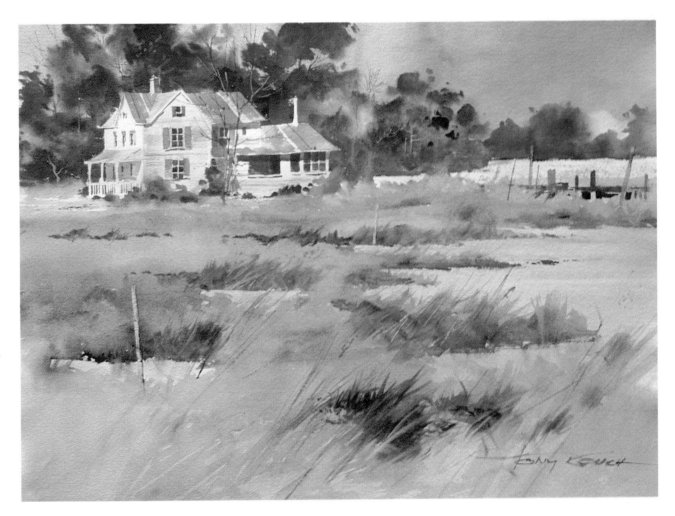

The Eastern Shore
22 × 30

In *The Eastern Shore*, the dominant shape is easily the house, since it is the largest single shape, and I've provided maximum value contrast around it. The dominant color temperature of the painting is warm, and with all the horizontal shapes and the horizontal dimension of the paper, I have a horizontal directional dominance.

Transition
22×30

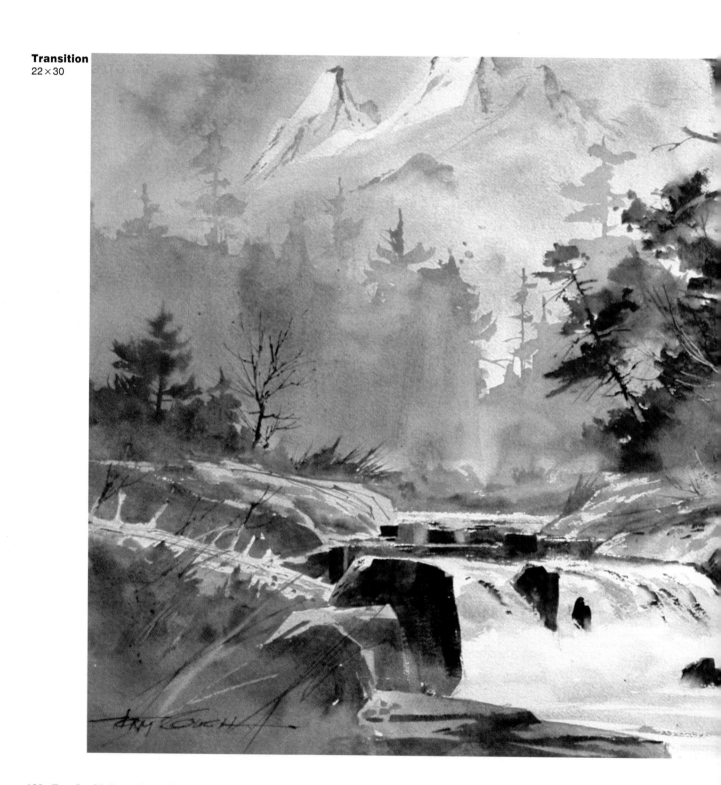

CHAPTER TWELVE
Paths for the Eye

What Is Composition and What Is Design?

S trictly speaking, composition is the process of composing or gathering components together into a unit. Speaking just as strictly, design is only another term for the same thing.

But I think of design as a larger, more complete, refinement of composition. While composition is the initial work and concerns itself with placement and size of shape and line, design concerns itself with that and the color, value and texture of these elements and how they will be used to create direction and unity.

Now that the semantics have been laid to rest, here are a few other concerns you will have when planning your painting.

Simplify

As a matter of good order for any painting, it's helpful to first ask ourselves, "What do I want to say?" or "What do I want to show my audience?" Then take the shape of the object that best expresses it—be it barn, flower, animal, machine or whatever—and make that the most important shape in the painting, the "star of the show."

Then make the other elements of the design the "supporting cast," which means they're in the painting but not as important as the star. Use them solely to "support" the star, the story you want to tell about it, or the mood you want to create with the star.

Next, eliminate any size, shape, line, direction, color, value or texture in the subject matter that isn't either the star or something that supports the star.

The Center of Interest

If only elements that support the star are included in the design, certainly the star will be at the center of interest. *Where* the center of interest is is important. The distance from it to all four sides of the painting should be different dimensions.

The reason? Variation. Either we vary the distance to the sides or we insure a less interesting placement of the center of interest. As a practical matter, then, there are only four places the center of interest can be in the rectangle, and that is over or very near the four crosses shown in the diagram.

The Middle of the Rectangle

The term *center of interest* doesn't mean center of the paper, but you'd never know it judging from the work of many a novice and not-so-novice painter. In fact, if we throw the center of interest on the paper with no thought to its placement, almost certainly it will be equidistant from at least two sides, and likely *precisely in the center* of the rectangle.

There's a reason for this: we're trained to do it from childhood! The how and why are not important here; what matters is that if you give a bowl of flowers to anyone and ask that person to place it on a table or mantle, we all know where it's going: right in the middle.

Place the center of interest so its distance from all four sides is different. The crosses show the four locations in a rectangle that fulfill this condition and are therefore good places to position the center of interest.

Conscious effort is required for proper placement. If we don't think "variety" in the initial sketch when placing the center of interest, by default it goes right in the middle.

For these reasons and others, painting/designing is a thinking exercise—something to do alone without distracting chatter from the group. Painting with your art club is a dandy idea for getting away from a greater distraction: the home. But once on location, split with the group and paint alone. Companions surely won't have read what you're reading here and may think your behavior is antisocial, so rejoin them later for lunch, critique or conviviality, but paint—and think—alone.

Take Us by the Hand
Having decided what to paint, how to present it, and where it will go in the rectangle, the artist's next task is to lead the audience into the painting, keep their attention in it, and direct the eyes to that most important spot, the center of interest.

The Foreground
See the foreground as merely the entryway into the painting. Don't burden the viewer with stumbling blocks there that distract the eye from where you want it to go—the center of interest. Whatever we put into the foreground will seem important since it is right up in front

in our face. Here are a few ways to keep the path clear:

1. Don't clutter up the foreground; keep it simple.

2. Still, *something* must be there, and the novice painter's eternal dilemma is what to put in the foreground. The easiest, most effective solution is gradation. Simple gradation of hue or value across the foreground, in any direction, will be enough. If you like more, a little splatter could be added, which always looks normal.

Such is the handling of the foreground in *Under Cover*, see page 104. I graded it light to dark, top to bottom. Aside from the splatter, I added a few blades of grass, but the painting would hold up without it.

3. If something big must go in the foreground, hide it. Keep it unimportant by making its value just different enough from its surrounding value to make it visible. Put little detail in it, like the building on the left in *Light in the Window*, on page 84.

4. If a fence must be in the foreground, never stretch it across the entire width of the painting with no break or you're telling the viewer, "Keep out of my painting!" Move the fence to the background, or pro-

Painting and designing is a thinking exercise, something to do alone without distracting chatter from the group. Painting out with your art club is a dandy idea, but once on location, paint—and think—alone.

Under Cover
22 × 30

Gradation is the easiest and most effective solution to the problem of what to put in the foreground. In *Under Cover*, the foreground is graded from top to bottom with addition of a few blades of grass and wheel tracks.

vide some way through the fence with an open gate or a break in it. For instance, in *Autumn at Eagan's* on page 61, the break in the fence does the job.

Similarly, you wouldn't want to put a felled tree or another long object entirely across the front of the painting without providing some kind of break in it to allow the audience into the painting.

Another option for a fence in the foreground is to hide it with close values, as was done with the build-

ing in *Light in the Window*. The fence in *Soft Touch* was handled this way and is hardly noticeable.

Depth

Creating the illusion of depth, or the third dimension, on our two-dimensional surface is always a good idea, but particularly if the center of interest is someplace other than the foreground. It helps lead the eye back into this center.

There are several ways to create the illusion of depth.

1. *Hue*: make things warm in the foreground and cool in the distance. Clouds are an exception. Paint them cool in the foreground and warm in the distance.

2. *Chroma*: make things brighter in the foreground and grayer in the distance.

3. *Detail*: put more in the foreground and none in the distance.

4. *Texture*: put rough texture (which appears to be detail) in the foreground and soft texture in the distance. Clouds are the exception again. Make the texture of the clouds soft in the foreground and hard/rough in the distance.

5. *Overlap*: Paint one shape partially covering another.

6. *Scale*: make things larger in the foreground; gradually reduce them in size with distance.

Although all are useful, scale is far more effective than any of the others. If scale is used, there *will be* depth, regardless of what is done with color, texture or detail. If scale

Soft Touch
22 × 30

The fence in the foreground provides a subtle lead into the picture, but because it is "hidden" by similar values it does not distract from the barn, which is the center of interest.

Walkin' in the Rain
22 × 30

There are a number of techniques used to create depth in this painting. Warm colors are used in the foreground; cool, grayed colors are used in the background. Detail and rough texture are reserved for the fore-ground. Overlap is used to establish what is close and what is far away. Finally, scale indicates relative sizes of things. The barn on the right is very large compared to the house on the left; the tree on the left is larger in the painting than the tree in the middle background, even though that tree would be much larger in reality.

Notice that long objects that extend from the foreground to the distance—such as the road—are very wide in the foreground and their size is greatly diminished as they recede into the distance.

is not used, there will be little depth, regardless of what is done with the rest.

As we found in chapter nine, it's important to use gradation in scale. That is, the shapes must *gradually* be reduced in size to make the picture plane recede. It's also important to greatly exaggerate the differences in size.

A landscape of rocks would have rocks of various size. Most of the large ones would be in the foreground, most mid-size rocks would be in the middle ground, and small rocks would be in the background. The difference in size between large and small rocks would be greatly exaggerated. In *The Presentation*, page 10, notice the great difference in the size of trees and rocks to create the illusion of distance.

The same technique would be used on trees, grass, buildings or whatever objects are used in the painting. *Caution:* Inexperienced painters tend to put large things in the foreground and small things in the background, but never anything in the middle ground, which eliminates the gradation.

Pay particular attention to long objects that extend from the foreground to the distance—such as roads, streams, fences and power lines. Like everything else in the foreground, they must be large, wide (in the case of roads and streams), or tall (in the case of fences and power poles). Like all other objects, their size should be greatly diminished as they recede. In addition, the width of the posts and the interval between them

should be gradually reduced with distance.

Caution: The inexperienced painter will typically understate the height and width of these things in the foreground. Bear in mind that it is impossible to make a road or stream too wide, or a power pole (even a fence post) too tall in the foreground.

Take a road, for instance. As the series of diagrams on the right show, it's impossible to overexaggerate the width of a road in the foreground. However, it can be understated, as shown in the first panel. In fact, inexperienced painters will almost always understate it. Look at how wide the road is in *Walkin' in the Rain*, left. I couldn't get it much wider!

The same principle is just as true for the height of power poles, trees and fence posts. You just can't make them too tall, but you can make them too short.

As this series of diagrams show, it's impossible to overexaggerate the width of a road in the foreground, but it can be understated as shown in the first panel. In fact, inexperienced painters will almost always understate this.

The inexperienced painter will typically understate the height and width of things in the foreground. Bear in mind it is impossible to make a road or stream too wide, or a power pole (even a fence post) too tall in the foreground.

Keeping the Eye in the Painting

Now that we've led the viewer into the painting, the job is to keep him there. It *is* possible to lead the viewer right back out of the painting. Here's how.

The Long Oblique

We're used to seeing a free-moving ball at rest against a vertical surface or on a perfectly level surface. But we've never seen a resting ball on an inclined surface; we know it would be rolling. In fact, the longer the surface and the steeper the incline, the faster the ball will travel toward the down side.

In the same way, our eyes rest on horizontal and vertical shapes and lines in a painting, but then travel toward the lower end of any vertical. And the longer and more acutely angled the line or shape is, the faster the eye will travel.

If the line or shape runs off the top, bottom or either side of the painting, the viewer's eye tends to travel right out of the picture.

If a line or shape runs off the top, bottom or either side of a painting, the viewer's eye tends to travel right out of the picture.

There are four ways to fix this problem:

1. *Don't do it*. Don't use long, oblique shapes or lines.

2. *Curb it*. If they *are* in the painting, turn them so they go off the side at or near right angles. In *Walkin' in the Rain*, on page 106, the diagonal left edge of the road turns perpendicular to the bottom of the painting before it runs off. The same happens where the right side of the road runs off the right side of the painting.

3. *Block it*. Put something over it before it gets to the edge of the painting. In *A Bit Brisk*, the diagonal slant of the facing barn's roof would run the eye off the right side of the painting except that it is blocked by the near building on the right.

4. *Hide it*. Make the value of it close to that around it so it's there, but we won't pay much attention to it. A good example of that is the fence in the foreground of *Soft Touch* on page 105.

A Bit Brisk
22 × 30

Putting something over an oblique that threatens to lead the viewer's eye off the painting effectively blocks its exit. In *A Bit Brisk*, the diagonal slant of the facing barn's roof would run the eye off the right side of the painting except that it is blocked by the near building on the right.

Rolling Home
22 × 30

A rule of thumb to remember is: Never point a vehicle out of a painting. Any auto, wagon, airplane or other vehicle points with its front end. It seems we know it moves and will look ahead of this vehicle to see where it can travel. A boat near the edge of the painting should be turned so it points *into* the design as in *Rolling Home*, right, not out, as in the diagram. Give a vehicle space in front of it so it looks as if it is moving into the picture, not out of it.

The Pointers
Any shape with a point directs the eye around or out of the painting, just as surely as an arrow or road sign. Obvious ones are the distant converging lines of roads, streams, fences and a series of power poles — but any pointed shape will do it. Some other objects without points are just as effective as pointers.

Any auto, wagon, airplane or other vehicle points with its front end. It seems we know it moves and

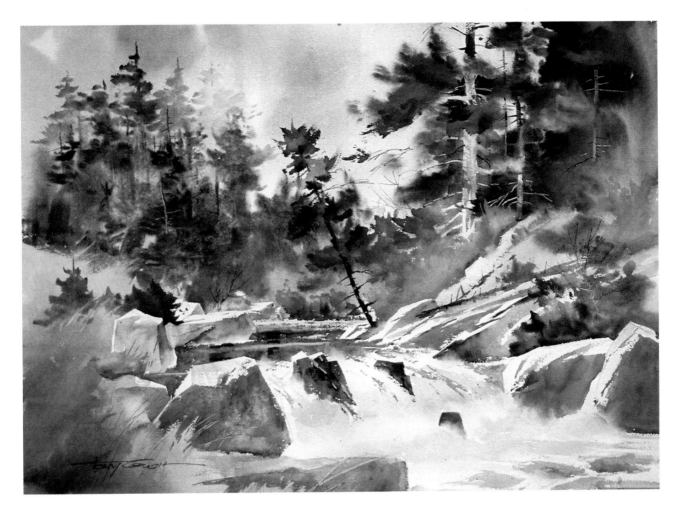

Big Thompson
22 × 30

The lightest light against the darkest dark in this painting occurs where the dark green water breaks into white water around the dark rocks, the center of interest. Maximum value contrast in one area—lightest light against the darkest dark—will move the eye directly to that spot, no matter what else we do with the painting. Value contrast is that arresting.

will look ahead of this vehicle to see where it can travel. So the rule of thumb is, never point a vehicle out of a painting. A boat, near the edge of the painting, should be turned so it points *into* the design as in *Rolling Home*, left—not out, as in the diagram. Another way to express the same thing is "Give the vehicle space in front of it in which to move."

The old theory that anyone who stands on a busy corner looking up will soon have everyone else looking up, is valid. We'll all look where we see someone else looking, even if it takes our eyes off the painting. So, like the auto, never have figures facing out of the painting. Always have them looking into it.

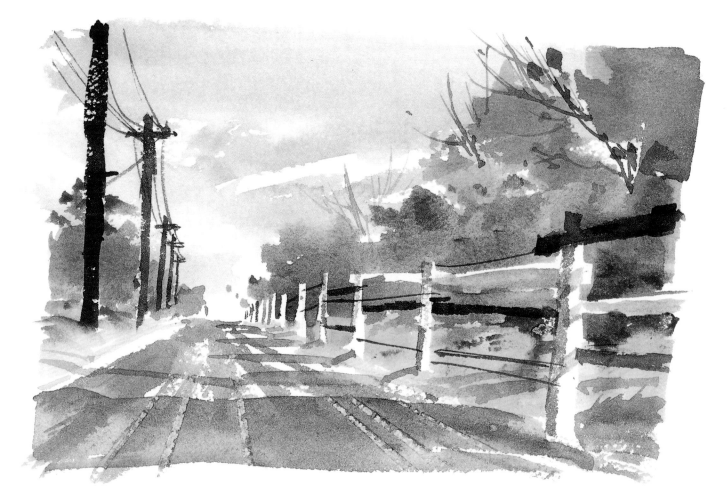

Lines and pointed shapes converging at one location are also irresistible pointers for the eye. In this sketch, the eye is taken to the center abruptly. If you use this device, make sure the eye isn't led into the exact middle of the rectangle, but to a point from which all four sides are different distances.

Journey's End

Now that we know how to keep the viewer in the painting, the last step is to lead the eye to that one area more important than any other, the center of interest.

There are several ways to do this, but two of them are more effective than the rest. "Maximum value contrast" is one; "radiation" is the other.

Maximum value contrast in one area (lightest light against the darkest dark) will move the eye directly to that spot, no matter what else we do with the painting. Value contrast is that *arresting*. This, of course, is assuming the eye is somewhere in the painting to begin with, not taken out of it as we discussed.

The lightest light against the darkest dark in *Big Thompson*, see page 111, occurs where the dark green water breaks into white water around the dark rocks. This area is the center of interest.

Radiation—a series of lines and pointed shapes converging at one location—will also sweep the eye directly to this spot, no matter what else we do with the painting, as shown in the sketch, left.

These straight lines and shapes take us *abruptly* to the center of interest. There may be times you would want to do it this way to dramatize speed, force or power, for instance. Generally speaking, however, we prefer a more gradual, graceful way of being led to a spot. It's easily done by modifying the radiation idea by using a graceful turn or two in the stream or road, or by using curved lines and shapes.

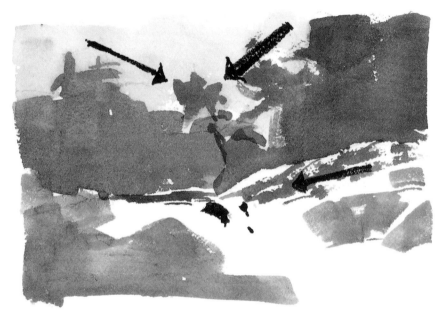

These may even direct us in a roundabout way to the center of interest.

A word of caution: You might use both radiation and maximum value contrast in the same painting to lead the viewer to your center of interest, but if you do, make sure they lead to the same center of interest! One device is as powerful as the other, and if they lead to different areas, you have created the confusion of two centers of interest.

Both devices are used in *Big Thompson*. The distant trees, the near trees and the middle distant rocks all angle down to the same spot (see diagram, above), which is also where the lightest dark is against the lightest light, the point at which the stream breaks into a waterfall.

Both value contrast and radiation are used in *Big Thompson*. The distant trees, the near trees and the mid-distant rocks all angle down to the same spot, which is also where the lightest dark is against the lightest light: the point at which the stream breaks into a waterfall.

When painting a darker shape behind a light shape, to make the light shape stand out, don't let the whole world know what you're doing. In *A*, right, the shape of the trees is too similar to that of the barn. *Don't* copy the contour of the light shape with the dark. Make them two independent shapes; even break the dark shape or use *two* dark shapes, as in *B*.

A

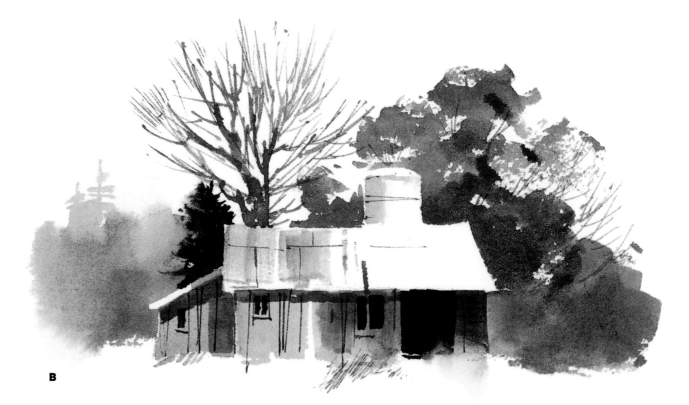

B

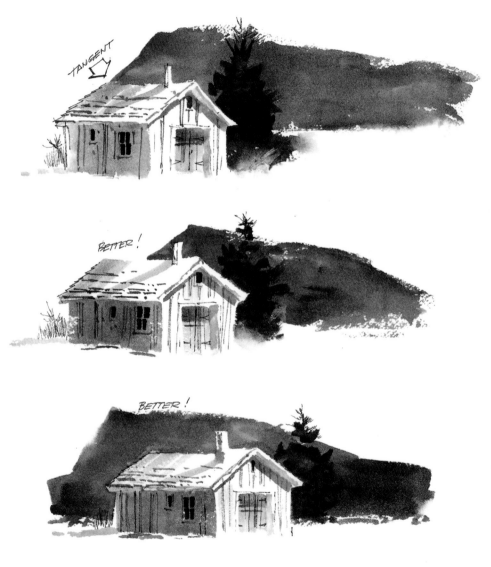

Beware the tangent! When two shapes are in close proximity, as is the background mountain and the cabin in the above sketch, allow some space between them or make them overlap, but never have the end or side of one coincide with the other.

Other Traps

Here are a few other snares into which the inexperienced painter has been known to fall:

1. When painting a darker shape behind a light shape to make the light shape stand out, don't let the whole world know what you're doing. *Don't* copy the contour of the light shape with the dark. Make them two independent shapes; even break the dark shape, or use *two* dark shapes.

2. Beware the tangent! When two shapes are in close proximity, allow some space between them or make them overlap, but never have the end or side of one coincide with the other. It's too confusing to the audience.

3. Suppose you were sitting in the backyard watching the kids play. One of them goes dashing behind a tree, but *another* child, or *nobody*, comes running out the other side! Wouldn't that be strange? Wouldn't you be confused?

Similarly, when running a long shape, line, area of color, value or texture behind a shape, don't stop it or change it behind that shape. Continue out the other side and *then* change or stop it out in the open so we know what happened!

In the top sketch, the background shape stops abruptly behind the tree. In the middle, it changes color and value. Either situation puzzles or confuses the reader. When running a long shape, line, area of color, value or texture behind a shape, don't stop it or change it behind that shape. Continue it on the other side and *then* change or stop it, out in the open, so we know what happened!

NO...

NO...

OK!

Used with the permission of William Hook.

Taos Thaw
by William Hook
30 × 30
acrylic on canvas

A square format is not as entertaining as one with two different dimensions and requires more thought than a vertical or horizontal one. In this painting by William Hook, the road, fence posts and puddles draw the viewer's eye into the painting to the building in the middle ground, the center of interest.

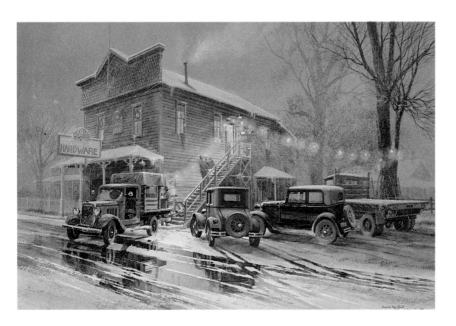

Deck the Halls
by Frank Loudin
16 × 24
watercolor

This painting by Frank Loudin is a great example of how an artist can lead the viewer's eye in a composition. The idea of this painting is to invite the viewer into a welcoming, warm place from a cold and snowy night. The direction of the tire tracks and the way the cars are parked point to the bottom of the stairs. The people going up the stairs to the lighted open door, accentuated by the colored lights, lead the viewer right into the center of interest.

Piggy Back
22 × 30

One Last Thought

I certainly don't mean to leave the impression that if you don't understand the eight principles of design, you cannot paint, that you're doomed to failure.

To the contrary, if you close this book now, throw it on the shelf and forget it, you'll be no worse off than when you first opened it. You can go on doing what you've done before. However, I've introduced—maybe reintroduced—you to eight of the best friends you'll ever have when you set out to paint.

I did this supposing that you were looking for something better out there and that with it *you* can do better. Sure, these eight friends are going to require some time and energy to get to know, but don't all friends? With time you'll learn that the better you know them, the more help they are each time you battle the rectangular painting surface.

How much trouble are they to learn and use? Consider what you're working with—eight principles that *can* be applied to each of seven elements. That means there are fifty-six things to keep track of while painting. Who in the world can keep up with that? No one, so relax.

That's why there will always be design errors in paintings. The only difference between superior paintings and lesser paintings is fewer and smaller mistakes.

Still, how can one wrestle with fifty-six items while trying to create superior paintings? Trying to do the whole thing in the beginning is a little like trying to conduct a three-ring circus; there's just too much going on. So here's an idea: Do a painting concentrating on just one of the principles—contrast, for instance—and let your intuition take care of the rest.

Then concentrate on another principle for your next painting, and so on, until you've worked your way through the list. When you're comfortable with that, try two principles at a time. Work your way through the list until you're comfortable with pairs, then try three at a time. Soon you'll be able to handle most or all of them in one painting. You'll see your work improving as your knowledge increases.

Please remember that although each of the principles *can* be applied to each element, it's rarely, if ever, done in one painting. If you have a dominance in three or four of your elements, for instance, be happy with that. You probably have a pretty good painting!

When the principles will be most useful to you is after the painting is finished, and you prop it up to critique what you've done.

Now you have few distractions and plenty of time to reflect upon the principles and how well they have been applied. You even have time to review them while you critique, where necessary.

Let me describe discouragement for you: it's painting a "knock out" painting—a beautiful job—well over your head and then realizing you can't do it again because you don't know what you've done!

Now here's encouragement: you paint a disaster—the worst you've ever seen—and you lock yourself in

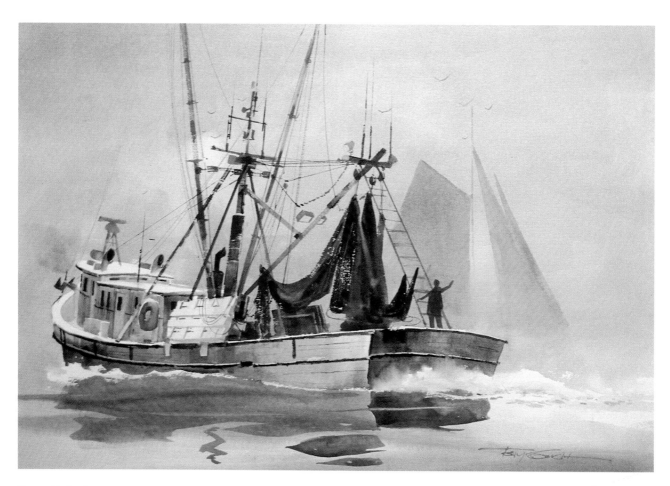

Dawn Patrol
22 × 30

a closet with it so no one else will know. Then you prop it up to see what you did wrong and you realize "Of course! It stinks because I made both those shapes the same size! And there's no color dominance here . . . and I lost my value pattern in the background! Next time, I won't make *those* mistakes; I'll work on my color dominance." *That's encouragement*.

Please remember that you're never going to be happy with your paintings. No professional ever is. The reason? Your knowledge will always be greater than your ability; you'll always know how to do it better than you're able.

Do you want to increase your ability? Increase your knowledge. You'll do that by studying books, watching videos, and attending workshops, but most of all, you'll teach yourself by painting and thinking, thinking and painting.

You will never be bored with this craft. There will always be a new idea, a better way that will have you bounding out of bed in the morning!

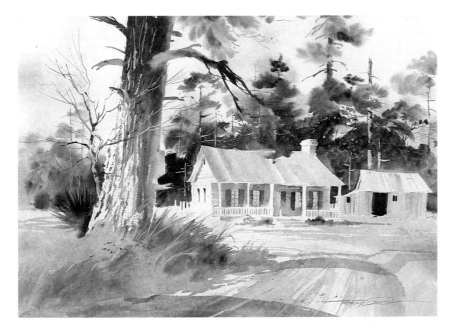

Pines
22 × 30

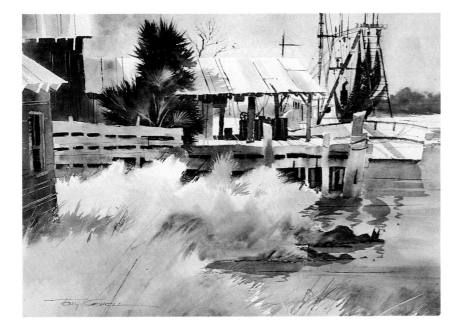

Dockside
22 × 30

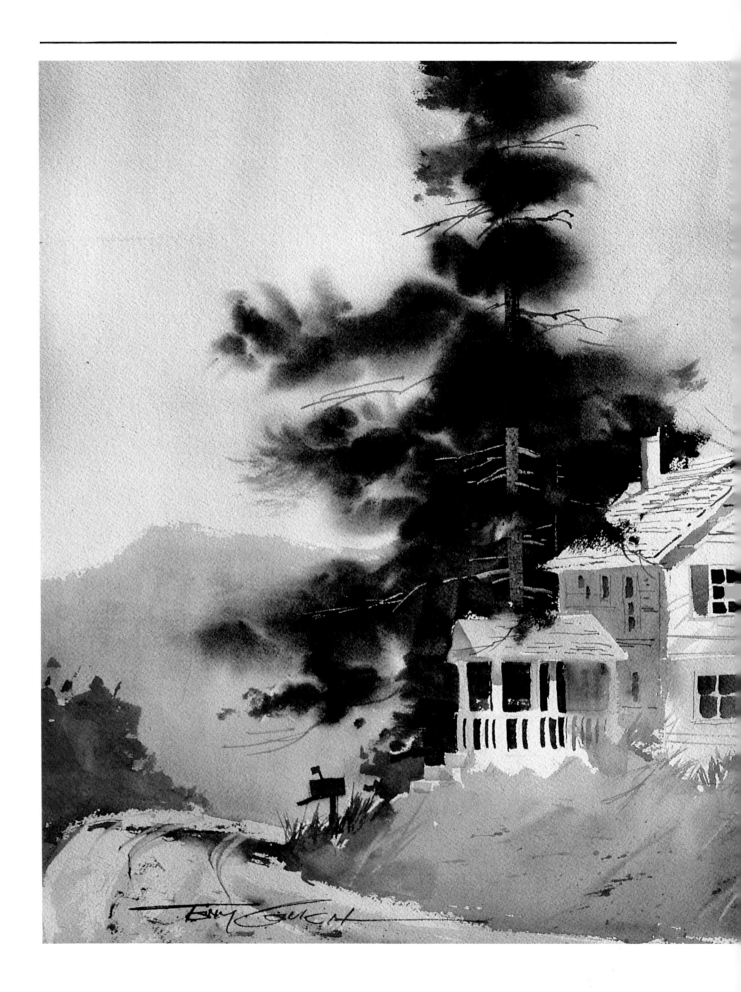

PERSISTENCE

Nothing in the world can take the place of persistence.
Talent will not;
nothing is more common than
unsuccessful men with talent.
Genius will not;
unrewarded genius is almost a proverb.
Education will not;
the world is full of educated derelicts.
Persistence and determination
alone are omnipotent.

Calvin Coolidge

Index

Improve your skills, learn a new technique, with these additional books from North Light

Graphics/Business of Art

Airbrush Artist's Library (6 in series) $5.95 each (cloth)

Airbrush Techniques Workbooks (8 in series) $9.95 each

Airbrushing the Human Form, by Andy Charlesworth $9.95 (cloth)

Artist's Friendly Legal Guide, by Floyd Conner, Peter Karlan, Jean Perwin & David M. Spatt $18.95 (paper)

Artist's Market: Where & How to Sell Your Graphic Art (Annual Directory) $22.95 (cloth)

APA #2: Japanese Photography, $69.95

Basic Desktop Design & Layout, by Collier & Cotton $27.95 (cloth)

Basic Graphic Design & Paste-Up, by Jack Warren $14.95 (paper)

The Best of Neon, edited by Vilma Barr $59.95 (cloth)

Business & Legal Forms for Graphic Designers, by Tad Crawford $19.95 (paper)

Business and Legal Forms for Illustrators, by Tad Crawford $15.95 (paper)

Business Card Graphics, from the editors of PIE Books, $34.95 (paper)

CD Packaging Graphics, by Ken Pfeifer $39.95

CLICK: The Brightest in Computer-Generated Design and Illustration $39.95 (cloth)

Clip Art Series: Holidays, Animals, Food & Drink, People Doing Sports, Men, Women, $6.95/each (paper)

COLORWORKS: The Designer's Ultimate Guide to Working with Color, by Dale Russell (5 in series) $24.95 ea.

Color Harmony: A Guide to Creative Color Combinations, by Hideaki Chijiiwa $15.95 (paper)

Complete Airbrush & Photoretouching Manual, by Peter Owen & John Sutcliffe $24.95 (cloth)

The Complete Book of Caricature, by Bob Staake $18.95

The Complete Guide to Greeting Card Design & Illustration, by Eva Szela $29.95 (cloth)

Creating Dynamic Roughs, by Alan Swann $12.95 (cloth)

Creative Director's Sourcebook, by Nick Souter and Stuart Neuman $34.95 (cloth)

Creative Self-Promotion on a Limited Budget, by Sally Prince Davis $19.95 (paper)

The Creative Stroke, by Richard Emery $39.95

Creative Typography, by Marion March $9.95 (cloth)

Design Rendering Techniques, by Dick Powell $29.95 (cloth)

The Designer's Commonsense Business Book, by Barbara Ganim $22.95 (paper)

The Designer's Guide to Creating Corporate ID Systems, by Rose DeNeve $27.95

The Designer's Guide to Making Money with Your Desktop Computer, by Jack Neff $19.95 (paper)

Designing with Color, by Roy Osborne $26.95 (cloth)

Desktop Publisher's Easy Type Guide, by Don Dewsnap $19.95 (paper)

Dynamic Airbrush, by David Miller & James Effler $29.95 (cloth)

Fashion Illustration Workbooks (4 in series) $4.50 each

59 More Studio Secrets, by Susan Davis $12.95 (cloth)

47 Printing Headaches (and How To Avoid Them), by Linda S. Sanders $24.95 (paper)

Getting It Printed, by Beach, Shepro & Russon $29.50 (paper)

Getting Started as a Freelance Illustrator or Designer, by Michael Fleischman $16.95 (paper)

Getting the Max from Your Graphics Computer, by Lisa Walker & Steve Blount $27.95 (paper)

Graphically Speaking, by Mark Beach $29.50 (paper)

The Graphic Artist's Guide to Marketing & Self-Promotion, by Sally Prince Davis $19.95 (paper)

The Graphic Designer's Basic Guide to the Macintosh, by Meyerowitz and Sanchez $19.95 (paper)

Graphic Design: New York, by D.K. Holland, Steve Heller & Michael Beirut $49.95 (cloth)

Graphic Idea Notebook, by Jan V. White $19.95 (paper)

Great Package Design, edited by D.K. Holland $49.95

Great Type & Lettering Designs, by David Brier $34.95

Graphics Handbook, by Howard Munce $14.95 (paper)

Guild 7: The Architects Source, $27.95 (cloth)

Guild 7: The Designer's Reference Book of Artists $34.95

Handbook of Pricing & Ethical Guidelines, 7th edition, by The Graphic Artist's Guild $22.95 (paper)

HOT AIR: An Explosive Collection of Top Airbrush Illustration, $39.95 (cloth)

How'd They Design & Print That?, $26.95

(cloth)

How to Check and Correct Color Proofs, by David Bann $27.95 (cloth)

How to Design Trademarks & Logos, by Murphy & Row $19.95 (paper)

How to Draw & Sell Cartoons, by Ross Thomson & Bill Hewison $19.95 (cloth)

How to Draw & Sell Comic Strips, by Alan McKenzie $19.95 (cloth)

How to Draw Charts & Diagrams, by Bruce Robertson $12.50 (cloth)

How to Find and Work with an Illustrator, by Martin Colyer $8.95 (cloth)

How to Get Great Type Out of Your Computer, by James Felici $22.95 (paper)

How to Make Money with Your Airbrush, by Joseph Sanchez $18.95 (paper)

How to Make Your Design Business Profitable, by Joyce Stewart $21.95 (paper)

How to Understand & Use Design & Layout, by Alan Swann $21.95 (paper)

How to Understand & Use Grids, by Alan Swann $12.95 (cloth)

How to Write and Illustrate Children's Books, edited by Treld Pelkey Bicknell and Felicity Trotman, $22.50 (cloth)

International Logotypes 2, edited by Yasaburo Kuwayama $24.95 (paper)

Labels & Tags Collection, $34.95 (paper)

Label Design 3, by the editors at Rockport Publishers $49.95

Legal Guide for the Visual Artist, Revised Edition by Tad Crawford $8.95 (paper)

Letterhead & Logo Designs 2: Creating the Corporate Image $49.95 (cloth)

Licensing Art & Design, by Caryn Leland $12.95 (paper)

Living by Your Brush Alone, by Edna Wagner Piersol $16.95 (paper)

Make It Legal, by Lee Wilson $18.95 (paper)

Making a Good Layout, by Lori Siebert & Lisa Ballard $24.95 (cloth)

Making Your Computer a Design & Business Partner, by Walker and Blount $27.95 (paper)

Marker Techniques Workbooks (8 in series) $4.95 each

New & Notable Product Design, by Christie Thomas & the editors of *International Design* Magazine $49.95 (cloth)

North Light Dictionary of Art Terms, by Margy Lee Elspass $12.95 (paper)

Papers for Printing, by Mark Beach & Ken Russon $39.50 (paper)

Preparing Your Design for Print, by Lynn John $27.95 (cloth)

Presentation Techniques for the Graphic Artist, by Jenny Mulherin $9.95 (cloth)

Primo Angeli: Designs for Marketing, $19.95 (paper)

Print Production Handbook, by David Bann $16.95 (cloth)

Print's Best Corporate Publications $34.95 (cloth)

Print's Best Logos & Symbols 2 $34.95 (cloth)

Print's Best Letterheads & Business Cards, $34.95 (cloth)

The Professional Designer's Guide to Marketing Your Work, by Mary Yeung $29.95 (cloth)

Promo 2: The Ultimate in Graphic Designer's and Illustrator's Promotion, edited by Lauri Miller $39.95

3-D Illustration Awards Annual II, $59.95 (cloth)

Trademarks & Symbols of the World: Vol. IV, $24.95 (paper)

Type & Color: A Handbook of Creative Combinations, by Cook and Fleury $39.95 (cloth)

Type: Design, Color, Character & Use, by Michael Beaumont $19.95 (paper)

Type in Place, by Richard Emery $34.95 (cloth)

Type Recipes, by Gregory Wolfe $19.95 (paper)

Typewise, written & designed by Kit Hinrichs with Delphine Hirasuna $39.95

The Ultimate Portfolio, by Martha Metzdorf $32.95

Using Type Right, by Philip Brady $18.95 (paper)

Art & Activity Books For Kids

Draw!, by Kim Solga $11.95
Paint!, by Kim Solga $11.95
Make Cards!, by Kim Solga $11.95
Make Clothes Fun!, by Kim Solga $11.95
Make Costumes!, by Priscilla Hershberger $11.95
Make Prints!, by Kim Solga $11.95
Make Gifts!, by Kim Solga $11.95
Make Sculptures!, by Kim Solga $11.95

Watercolor

Basic Watercolor Techniques, edited by Greg Albert & Rachel Wolf $14.95 (paper)

Buildings in Watercolor, by Richard S. Taylor $24.95 (paper)

Chinese Watercolor Painting: The Four Seasons, by Leslie Tseng-Tseng Yu $24.95 (paper)

The Complete Watercolor Book, by Wendon Blake $29.95 (cloth)

Fill Your Watercolors with Light and Color, by Roland Roycraft $28.95 (cloth)

Flower Painting, by Paul Riley $27.95 (cloth)

How to Make Watercolor Work for You, by Frank Nofer $27.95 (cloth)

Jan Kunz Watercolor Techniques Workbook 1: Painting the Still Life, by Jan Kunz $12.95 (paper)

Jan Kunz Watercolor Techniques Workbook 2: Painting Children's Portraits, by Jan Kunz $12.95 (paper)

The New Spirit of Watercolor, by Mike Ward $21.95 (paper)

Painting Nature's Details in Watercolor, by Cathy Johnson $22.95 (paper)

Painting Watercolor Portraits That Glow, by Jan Kunz $27.95 (cloth)

Splash I, edited by Greg Albert & Rachel Wolf $29.95

Starting with Watercolor, by Rowland Hilder $12.50 (cloth)

Tony Couch Watercolor Techniques, by Tony Couch $14.95 (paper)

The Watercolor Fix-It Book, by Tony van Hasselt and Judi Wagner $27.95

Watercolor Impressionists, edited by Ron Ranson $45.00 (cloth)

The Watercolorist's Complete Guide to Color, by Tom Hill $27.95

Watercolor Painter's Solution Book, by Angela Gair $19.95 (paper)

Watercolor Painter's Pocket Palette, edited by Moira Clinch $15.95 (cloth)

Watercolor: Painting Smart, by Al Stine $27.95 (cloth)

Watercolor Tricks & Techniques, by Cathy Johnson $21.95 (paper)

Watercolor Workbook: Zoltan Szabo Paints Landscapes, by Zoltan Szabo $13.95 (paper)

Watercolor Workbook: Zoltan Szabo Paints Nature, by Zoltan Szabo $13.95 (paper)

Watercolor Workbook, by Bud Biggs & Lois Marshall $22.95 (paper)

Watercolor: You Can Do It!, by Tony Couch $29.95 (cloth)

Webb on Watercolor, by Frank Webb $29.95 (cloth)

The Wilcox Guide to the Best Watercolor Paints, by Michael Wilcox $24.95 (paper)

Mixed Media

The Art of Scratchboard, by Cecile Curtis $23.95 (cloth)

The Artist's Complete Health & Safety Guide, by Monona Rossol $16.95 (paper)

The Artist's Guide to Using Color, by Wendon Blake $27.95 (cloth)

Basic Drawing Techniques, edited by Greg Albert & Rachel Wolf $14.95 (paper)

Being an Artist, by Lew Lehrman $29.95

Blue and Yellow Don't Make Green, by Michael Wilcox $24.95 (cloth)

Bodyworks: A Visual Guide to Drawing the Figure, by Marbury Hill Brown $24.95 (cloth)

Business & Legal Forms for Fine Artists, by Tad Crawford $4.95 (paper)

Calligraphy Workbooks (2-4) $3.95 each

Capturing Light & Color with Pastel, by Doug Dawson $27.95 (cloth)

Colored Pencil Drawing Techniques, by Iain Hutton-Jamieson $24.95 (cloth)

The Complete Acrylic Painting Book, by Wendon Blake $29.95 (cloth)

The Complete Book of Silk Painting, by Diane Tuckman & Jan Janas $24.95 (cloth)

The Complete Colored Pencil Book, by Benard Poulin $27.95 (cloth)

The Complete Flower Arranging Book, by Susan Conder, Sue Phillips & Pamela Westland $24.95

The Complete Guide to Screenprinting, by Brad Faine $24.95 (cloth)

Tony Couch's Keys to Successful Painting, by Tony Couch $27.95

Complete Guide to Fashion Illustration, by Colin Barnes $11.95 (cloth)

The Creative Artist, by Nita Leland $27.95 (cloth)

Creative Basketmaking, by Lois Walpole $12.95 (cloth)

Creative Paint Finishes for the Home, by Phillip C. Myer $27.95

Creative Painting with Pastel, by Carole Katchen $27.95 (cloth)

Decorative Painting for Children's Rooms, by Rosie Fisher $10.50 (cloth)

The Dough Book, by Toni Bergli Joner $15.95 (cloth)

Drawing & Painting Animals, by Cecile Curtis $26.95 (cloth)

Drawing: You Can Do It, by Greg Albert $24.95

Exploring Color, by Nita Leland $24.95 (paper)

Festive Folding, by Paul Jackson $17.95 (cloth)

The Figure, edited by Walt Reed $16.95 (paper)

Fine Artist's Guide to Showing & Selling Your Work, by Sally Price Davis $17.95 (paper)

Getting Started in Drawing, by Wendon Blake $24.95

Great Gifts You Can Make in Minutes, by Beth Franks $15.95 (paper)

The Half Hour Painter, by Alwyn Crawshaw $19.95 (paper)

Handtinting Photographs, by Martin and Colbeck $29.95 (cloth)

How to Paint Living Portraits, by Roberta Carter Clark $27.95 (cloth)

How to Succeed As An Artist In Your Hometown, by Stewart P. Biehl $24.95 (paper)

Introduction to Batik, by Griffin & Holmes $9.95 (paper)

Keys to Drawing, by Bert Dodson $21.95 (paper)

Light: How to See It, How to Paint It, by Lucy Willis $19.95 (paper)

Make Your Own Picture Frames, by Jenny Rodwell $12.95 (paper)

Make Your Woodworking Pay for Itself, by Jack Neff $16.95 (paper)

Master Strokes, by Jennifer Bennell $27.95 (cloth)

The North Light Handbook of Artist's Materials, by Ian Hebblewhite $4.95 (cloth)

The North Light Illustrated Book of Painting Techniques, by Elizabeth Tate $29.95 (cloth)

Oil Painting: Develop Your Natural Ability, by Charles Sovek $29.95

Oil Painting: A Direct Approach, by Joyce Pike $22.95 (paper)

Oil Painting Step by Step, by Ted Smuskiewicz $29.95

Painting Floral Still Lifes, by Joyce Pike $19.95 (paper)

Painting Flowers with Joyce Pike, by Joyce Pike $27.95 (cloth)

Painting Landscapes in Oils, by Mary Anna Goetz $27.95 (cloth)

Painting More Than the Eye Can See, by Robert Wade $29.95 (cloth)

Painting Seascapes in Sharp Focus, by Lin Seslar $22.95 (paper)

Painting the Beauty of Flowers with Oils, by Pat Moran $27.95 (cloth)

Painting the Effects of Weather, by Patricia Seligman $27.95

Painting Towns & Cities, by Michael B. Edwards $24.95

Painting with Acrylics, by Jenny Rodwell $19.95 (paper)

Pastel Painter's Pocket Palette, by Rosalind Cuthbert $16.95

Pastel Painting Techniques, by Guy Roddon $19.95 (paper)

The Pencil, by Paul Calle $19.95 (paper)

Perspective Without Pain, by Phil Metzger $19.95

Photographing Your Artwork, by Russell Hart $18.95 (paper)

Putting People in Your Paintings, by J. Everett Draper $19.95 (paper)

Realistic Figure Drawing, by Joseph Sheppard $19.95 (paper)

Tonal Values: How to See Them, How to Paint Them, by Angela Gair $19.95 (paper)

To order directly from the publisher, include $3.00 postage and handling for one book, $1.00 for each additional book. Allow 30 days for delivery.

North Light Books
1507 Dana Avenue, Cincinnati, Ohio 45207
Credit card orders
Call TOLL-FREE
1-800-289-0963
Prices subject to change without notice.